DESIGNERS DESIGN FOR THEMSELVES

DESIGNERS DESIGN FOR THEMSELVES

Inside the Charming Old Homes of Fourteen Trend Setters and Talents in American Arts and Design

Patricia Corbin

Photographs by

Ernst Beadle

E.P. DUTTON NEW YORK

First published, 1980, in the United States by E. P. Dutton, a division of
Elsevier-Dutton Publishing Co., Inc., New York.

For information contact: Elsevier-Dutton Publishing Co., Inc., 2 Park
Avenue, New York, N.Y. 10016

Library of Congress Catalog Card Number: 79-53330
ISBN: 0-525-93135-X

Text set by Expertype, Inc., New York
Printed and bound in Hong Kong by South China Printing Co.

Published simultaneously in Canada by Clarke, Irwin & Company Limited,
Toronto and Vancouver

10 9 8 7 6 5 4 3 2 1

First Edition

Designed by Jacqueline Schuman

CONTENTS

PREFACE

Love of home and hearth has always been an American passion, but what a dilemma it must have been to furnish a house back in the 1870s. Think of the style choices: Indian, Moorish, Gothic, Tudor, Empire, Adam, Sheraton, Hepplewhite, Jacobean, and the three French kings; not to mention Sears & Roebuck, Grand Rapids, Japanese, and Chinese influences. At the time *The Decorator & Furnisher* didn't help—the issues were filled with advice on how to use stuffed bears for dumbwaiters or drape mantels with velvet and gold fringe. Ladies actually tried to follow the decorating trends, and consequently their rooms often looked more bizarre than beautiful. But somehow in looking back through all the bric-a-brac and lambrequins, one abiding quality does shine out from those Victorian embellishments: the quality of personality.

If anything, that sense of personality outweighs all the words written about the excesses and vulgarity of the Victorian period. Thank goodness, too, it was a bonanza for design and decoration, and that the surge in building produced all those Colonials, Queen Anne cottages, and Georgian Revivals. So many architectural riches make it so much more fun for us now.

America has always had a tear-down, build-up philosophy: we're always going through confusions and uncertainties along with giant advances in technology. Call it historical revivalism, nostalgia for the past, romanticism, whatever; but ever since our country began to grow and become complex, there has been something enormously appealing about the enduring charms of ancestral places. Today, more than ever, our old houses have never looked so inviting, so interesting, so desirable for homemaking. We're fortunate that fourteen of America's professional artists, designers, and serious collectors have allowed photographs of their old houses to be published in this book.

Some go back to the 1700s; some are big, others are tiny. They range from sprawling barns to little shacks, and each has a special character and charm that reflect the owners' deep regard for the past and affection for traditional American life.

The interiors are all personally decorated in very stylish ways, stylish in the sense that they show great taste, warmth, and appreciation of the fine arts. They are livable and appealing, but perhaps the most outstanding quality they share is their human beingness—the rooms are filled with personality. They display many ideas for living the good life: ways with color, pattern, possessions; talent in putting things together, and arrangements for hospitableness and comfort.

Barry Bishop

MOODY MOUNTAIN FARM
AND GUEST HOUSE

A house owned by the same family for centuries is a classic example of a New Hampshire cape style. Although the original homestead has been enlarged, drastically changed and embellished inside, essentially the main structure is the basic frame put up by Abner Moody, a Revolutionary War soldier. When he took over the territory it was Indian land, but it had been given to him as a free grant from the government for his services in the war. He built his four-room house right in the center of a mountain range, and in only a year's time he'd turned the property into a successful farm. Generations of Moodys followed, all tilling the land, and through the years changing the house to suit their living styles.

What has lasted until today is the modernization that began in 1900: partitions between rooms were taken down, more windows were added, ceilings were raised, and a summer porch was tacked on. But whatever was changed, the owners managed to keep the feeling of the place warm and friendly. Each generation added to the furniture, so it covers many periods, ranging from farm to sophisticated English pieces. Colors are soft and muted, with the rich patterns of old rugs, chintzes, and collections of china adding character.

When Barry Bishop came to the Moody house, he was the first nonrelative to live there. In decorating the place he kept everything of the Moodys in use and simply rearranged things to his advantage. He was amazed to find that when he added his own possessions to the rooms, they looked as if they had always belonged.

If there is a style to the house, it could be called American Lived-In, comfortable and cozy, not a decorated look but certainly not without flair. It is remarkable that furniture covering a time span longer than a century can look so right in decorating today. One can imagine sitting in the kitchen and having a wonderful time, with the old Oakland "A" model stove pumping out heat and all the food served being fresh from the garden. It has an ambiance and a genial spirit that show how the evolution of living can be just as decorative as the fanciest put-together environment.

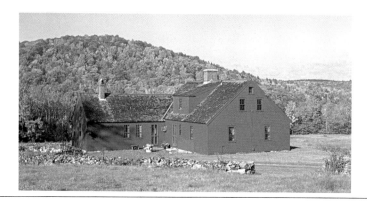

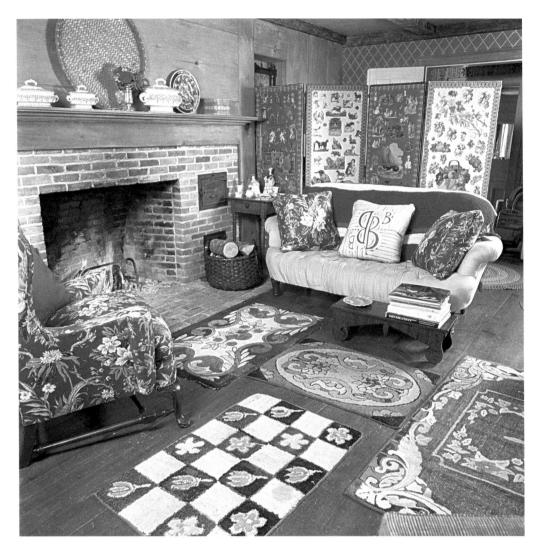

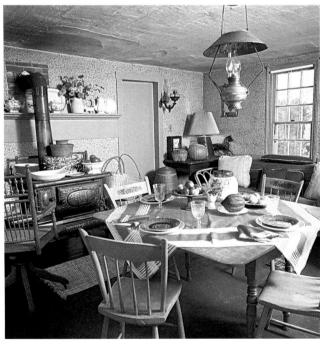

△ What was originally two small rooms is now the living room, with its handsome paneling of wide pine boards and the polished pine flooring, a nice background for showing off a collection of hooked rag rugs. The tufted sofa is a Victorian piece, as is the decoupaged screen behind it. The wing chair and pillows are covered in an old-fashioned hand-blocked glazed linen from England. The china is Staffordshire and American ironstone.

▷ The kitchen, which is in the main part of the original house, is sort of an everything room. One side looking out toward the front yard is set up for desk work; the opposite wall has a glider-sofa for reading, and the cooking part faces the old iron stove. Furnishings are unpretentious: a maple table, Windsor chairs, a spindle-back swivel rocker, ironstone and green majolica ware for china.

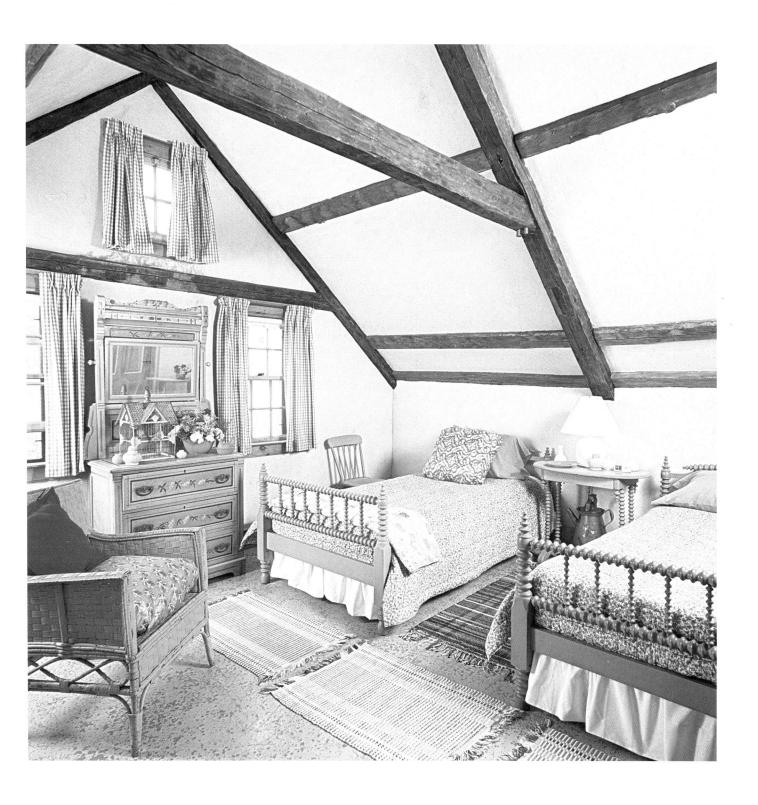

An upstairs bedroom was given a cathedral feeling when the original low ceiling was taken down to reveal hand-pinned support beams. The spool beds and the night table are painted blue to harmonize with the cottage piece, an Eastlake bureau. The wooden floors are splatter-painted and laid with handwoven cotton rugs. The wicker chair is made of raffia, and the curtains are checked gingham.

The Guest House

In the eighteenth century this little house, which used to be divided into four rooms, was a blacksmith's shop for over fifty years. In the early 1900s it was moved from an adjoining farm, a bath was added, and it was converted and rented out to summer boarders. Recently all the partitions and wall-boarding were taken away and the ceiling was knocked down, turning it into a one-room house. Up in the attic rafters a platform was constructed for sleeping, and bigger windows were added along one wall looking out over the glorious mountain view.

The whole space is furnished with a mélange of leftovers: a Moroccan rug, a red-lacquered lawn chair, and a coffee table fashioned from painted barn boards. The birdhouses were made by a local craftsman. The raw-wood look of some of the overhead beams was achieved by the painter, who never finished his whitewash job.

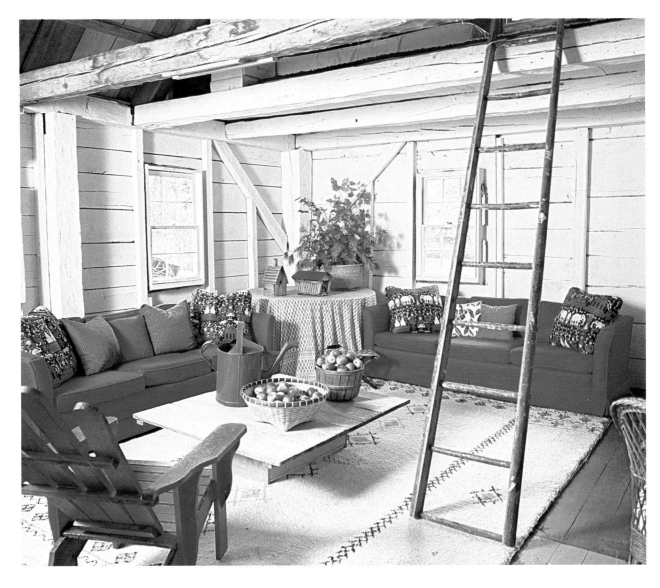

Stephen Mazoh
PLEASANT PLACE

Dating back to the early nineteenth century, this handsome building was the center and municipal headquarters of a small village. In 1830 when the first part was originally built, it was a one-room schoolhouse with living quarters above for the teacher. Around 1860 when the main structure was added, it was optimistically designed to become the county courthouse. The distinction was short-lived, for the village did not prosper into a metropolis; instead, trade moved on, leaving a rural backwater with only a few country stores enclosed by vast farmlands.

For almost a century Pleasant Place has been a horse farm. The house encompasses the old schoolroom (now the library), the main courthouse (living room and dining room), and a nearby milking barn was added for the kitchen. Ceilings were raised, and in some rooms pine beams from an adjacent millhouse were put overhead; new floors were laid of pine and Pennsylvania bluestone.

The house is filled with collections: Hudson River Valley landscapes, folk-art portraits, earthenware, tinware, and Japanese lacquerware. The distinguished art and objects intermingle throughout, and everything has been arranged by the owner to please himself. The decorating has a vitality that comes from his appreciation of fine furniture and paintings, plus the wit to cluster the unexpected together. Nothing remains static—often things are moved around and completely changed to make room for new acquisitions. The look is assured and not labored, and the mix of styles and periods is skillful without being chaotic.

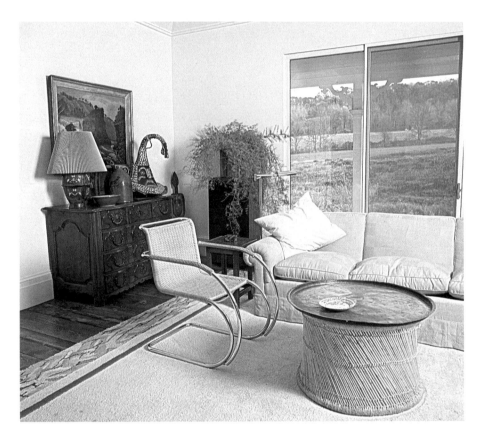

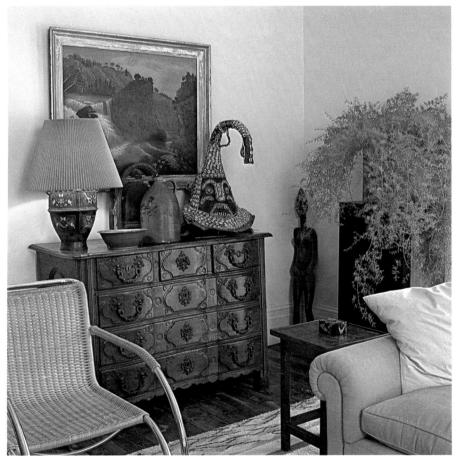

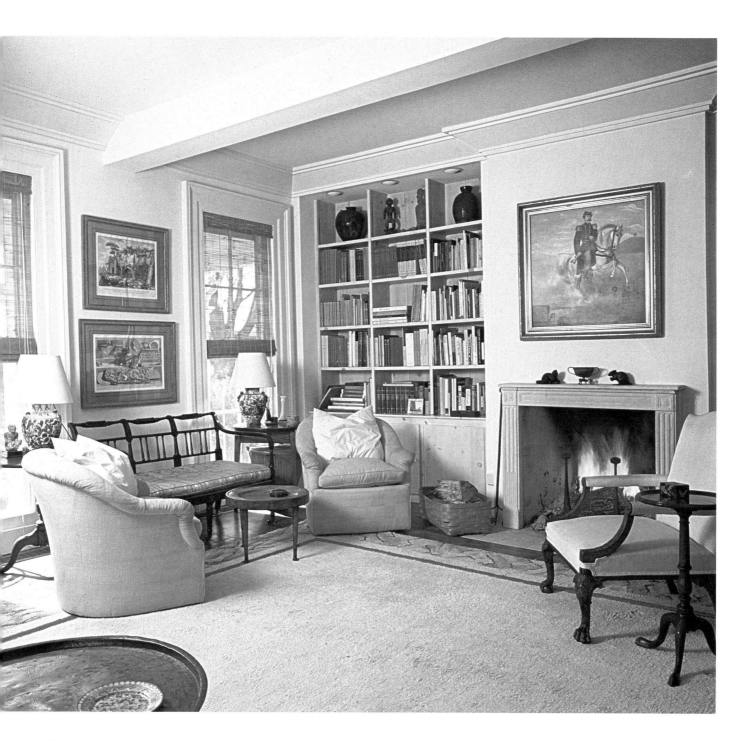

Cheerful and inviting, the living room is warmed by eclectic
pictures: a portrait of a Civil War officer, Italian engravings,
Hudson River Valley landscapes. The diversity of the collec-
tion shows some surprising go-togethers: a sophisticated
French provincial walnut chest has a primitive beaded head-
dress from Zaïre; a Tibetan gong close by a Bennington
stoneware jug; and nearby a carved African figure stands
under the asparagus fern. The furniture is just as compatible:
a Mies van der Rohe chair of cane and chrome is a classic
shape along with the Chippendale armchair and the English
Regency settee.

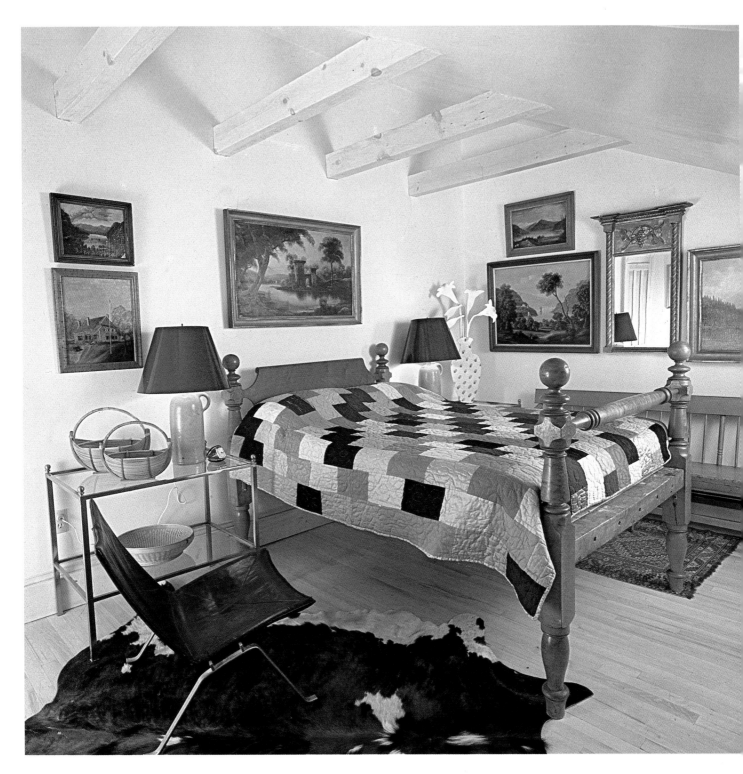

Romantic landscape paintings surround the walls of a guest bedroom painted shiny white. The maple bed is covered with a graphic patchwork quilt; the lamps are Bennington stoneware. Somehow the glass tables, leather sling chair, and calfskin rug don't look at all incongruous with the Americana things. *Lilies in a Vase* beside the bed is a carved and painted contemporary sculpture by Moe McDermott.

16

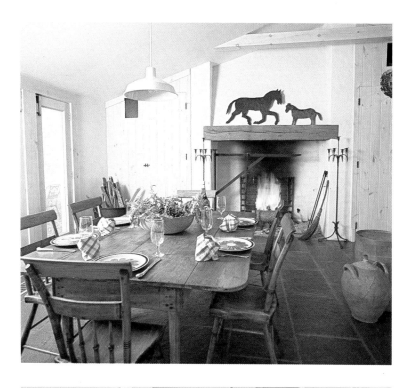

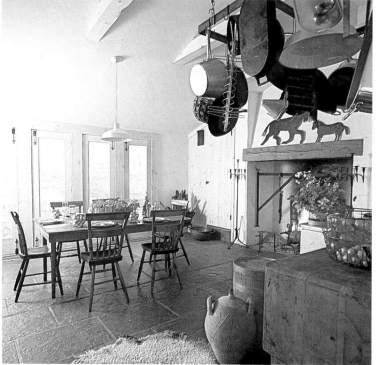

The huge fireplace designed by the owner heats the kitchen like a furnace and is equipped to roast, grill, and bake, as in an eighteenth-century house. The mantel, made of an old barn beam, holds folk-art weathervanes, and nineteenth-century American candlesticks stand on either side of the fireplace. The working side of the kitchen, opposite the country table and chairs, is curved around a big, center butcher's block.

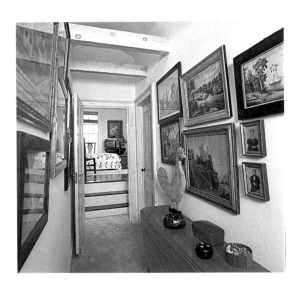

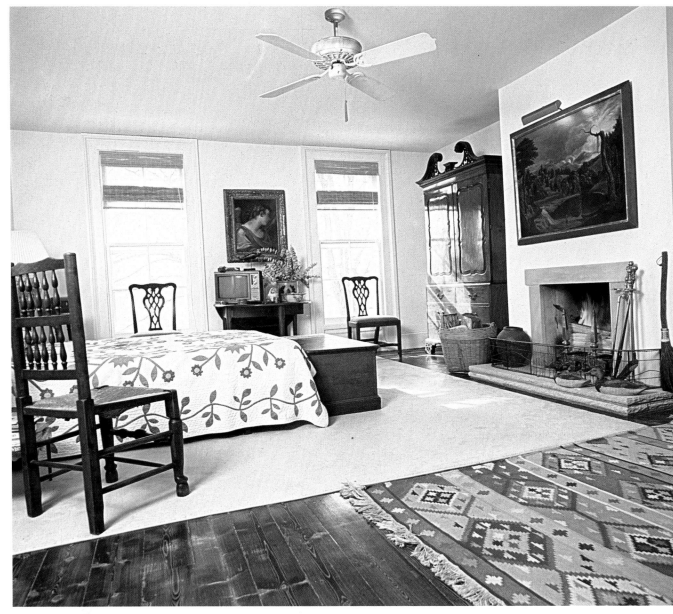

◁ The narrow upstairs hall is paved with a rich display of nineteenth-century paintings; the objects on the early American table are Japanese lacquerware pieces and an American rooster weathervane carved of pine.

▽ Again, white walls make a serene background for a bedroom filled with superb art and furniture. The mahogany corner piece is English; the chairs are Chippendale; the oak side chair beside the bed is early Jacobean. For different patterns and colors, quilts and rugs are changed often from the owner's collection of patchwork, kilims and dhurries.

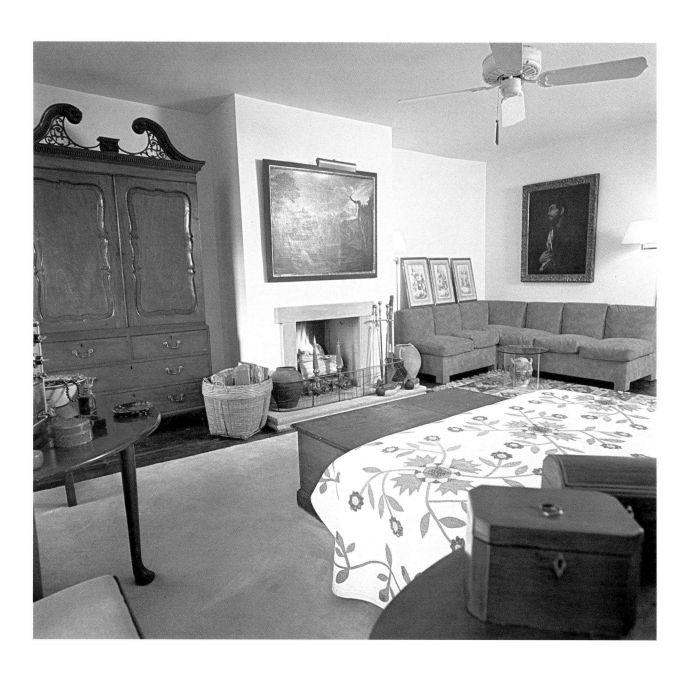

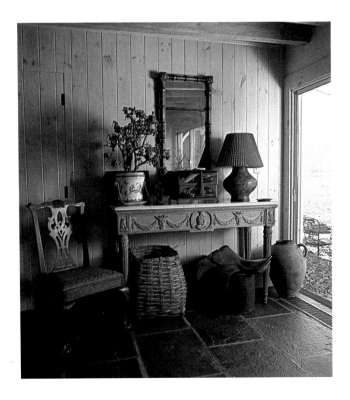

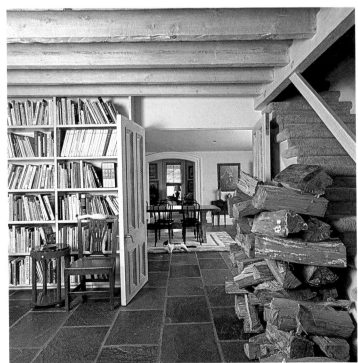

△ The front hall is filled with clues to the owner's interests: On one side sits his saddle underneath an elegant Adam console table carved of pine. A French crock and an American Indian basket share the space too. There is an American Chippendale chair, a Federal-style gilt mirror, and on top of the table a Chinese cloisonné lamp with an eighteenth-century Japanese lacquered box and a jade plant in a contemporary porcelain cache-pot. The opposite side holds the owner's art reference library, and (perhaps just as valuable) his carefully stacked woodpile. Beyond is the dining room.

▷ The spartan quality of the dining room is enhanced by a clean white expanse of walls, spotlighted with one important folk-art portrait. The Hepplewhite-style table is American; the twisted brass candlesticks are English; the bentwood chairs are modern; and the Japanese jugs are early eighteenth century.

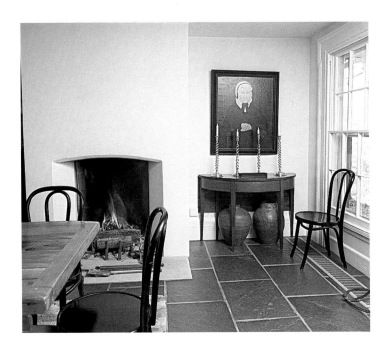

Julia Walker
LONE PINE

It is so high up in the Adirondack Mountains that to reach Lone Pine one has to ascend a twisting, almost perpendicular road, but once there, the view is one of the most spectacular anywhere. How the house came to be is the result of a sort of getting-back-to-nature feeling that swept America just after the turn of the century: in the middle of rapid industrialization and technology, rusticity became a favorite pursuit, and there were many sprawling houses built in the mountains for the purpose of nurturing pioneer spirits.

Lone Pine was built in 1903, generously fashioned for legions of children and relatives with a multitude of bedrooms, sitting rooms, and a covered porch meandering along the scenic side of the house. A separate cookhouse and dining room (connected to the big house with wooden plank walkways) had servants' rooms above.

The house was unheated and used only one or two months in the summer, but it had been lived in continuously since it was built. The place was bought with some of the original furnishings still there and the new owners had no repairs or changes to make; they simply swept out the cobwebs and moved in.

Their style is Adirondack Rustic, keeping the atmosphere camplike for emphasis on the outdoor sports of mountain hiking, picnicking, swimming, and careening down the valley river in rubber inner tubes. No fuss is made over decor. The joy is in nature and the flavor is woodsy and sporty.

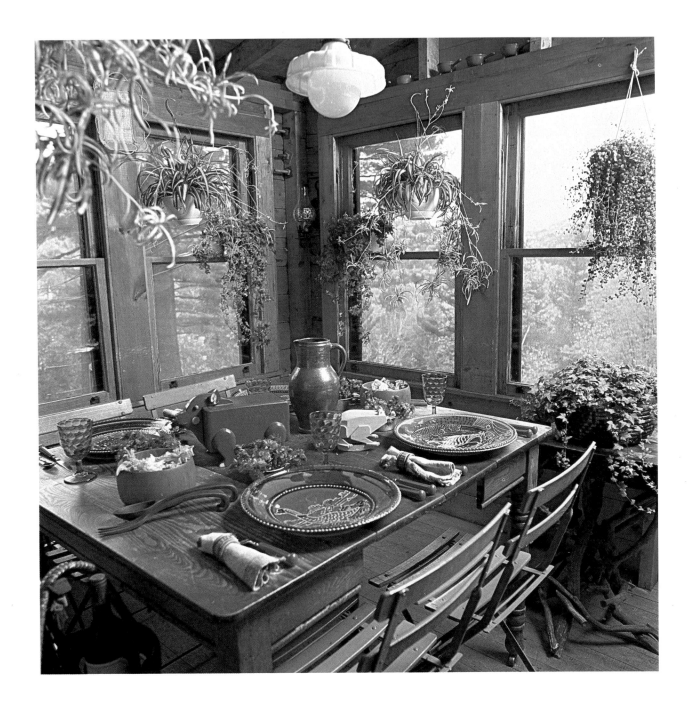

△ In the cookhouse what was once the servants' dining room is now the family breakfast room. It has a panoramic view of the mountains, and with its rustic furnishings, it exemplifies the camp spirit. The table is a kitchen-type; fold-up, French park chairs do for seating. The glazed earthenware plates are by Douglas Fey in the sgraffito style; the wooden pig and the frog are modern folk pieces. An English ivy plant sits on an antique Adirondack stand made from tree roots.

▷ The big sitting room achieves a feeling of nature, with earth colors, stone, wood, and wicker being the elements. It has a place for everyone to be cozy, including the family dog.

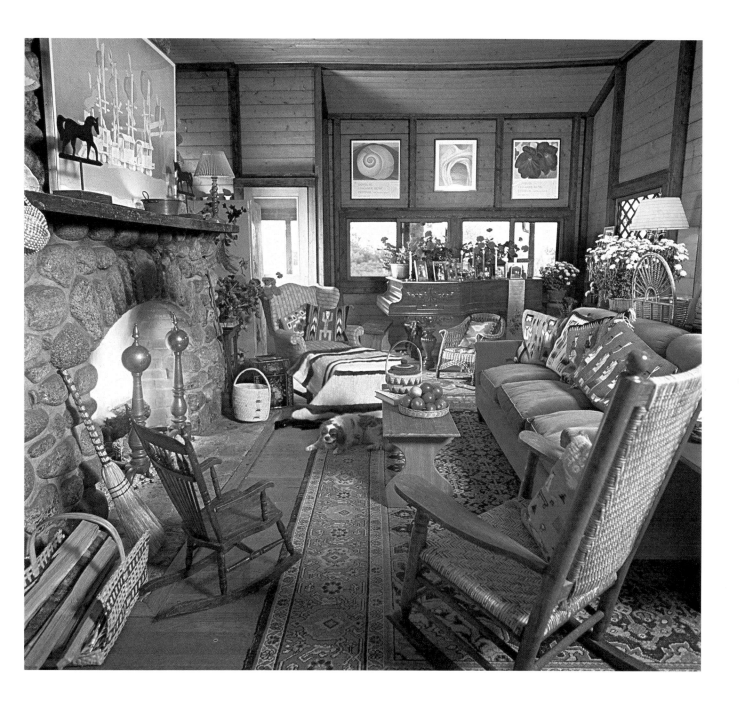

Behind the sofa there are game tables and corners for reading; the furniture is strictly for comfort and easy care. There are handwoven Indian pillows collected from the Museum of the American Indian, lots of baskets, and a handcrafted coffee table done in the Shaker style. The diversity of chairs, along with the ornately carved Victorian piano, the old Persian rug, and the modern Georgia O'Keeffe posters, all seem to get along happily. The mantel holds a pair of handcarved spool lamps, an iron horse by Elizabeth Braun, and a lithograph by William Crutchfield. The fur afghan is a combination of three generations of a family's old ermine and mink coats.

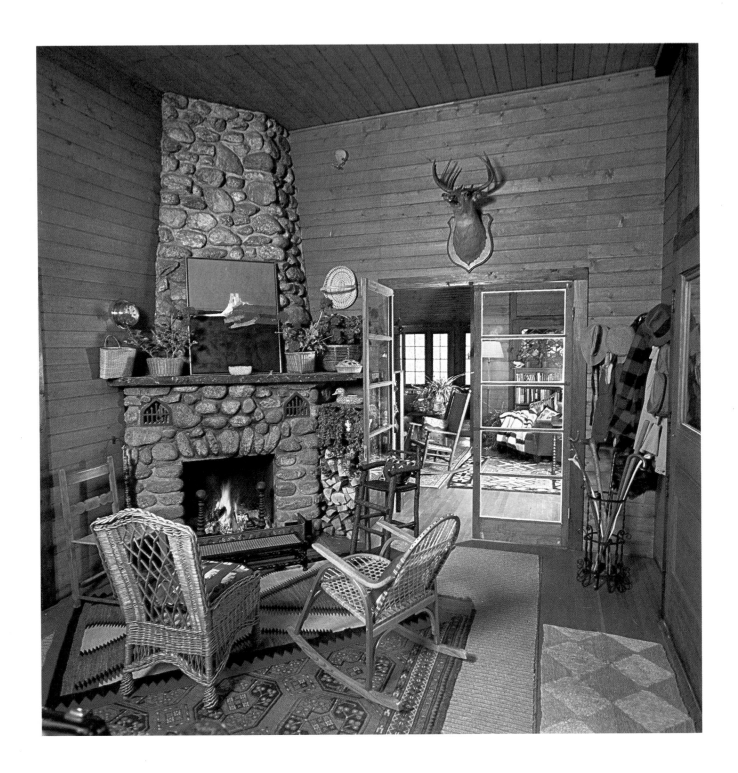

The great hall is designed as a welcoming and warming entrance: pegs for hanging gear line the walls on either side of the front door; chairs drawn up to the fire offer a variety of seating. The snowshoe and rawhide rocker as well as the birch ladder-back side chair are made locally; the bark high-chair is an antique from the area, as is the wicker lattice-back chair with ratchet feet. The painting over the mantel is by Douglas Hamilton-Fraser.

Yorke Kennedy
LATIMER

In the deep countryside two old barns, built back-to-back and completely dilapidated, didn't look like a possible weekend retreat at all. The condition was worse than terrible—nothing much was left of the 1870s structure. The siding had almost completely rotted away, and what was left hung like curtain swags on the ground.

It looked too hopeless, but Latimer was bought, partly out of pity for the state of the place but mostly out of love for the setting. The project became a passion for the new owner who rehabilitated the barns (without an architect) into an unexpected expression of urbane design. His house is a place of wonderful elegance disguised and encased in a rustic shell. The decoration is sumptuous, and all the more vivid in contrast to the stark exterior and the rural surroundings. It is filled with treasures collected on both sides of the Atlantic and blended in a most unselfconscious style. And most impressive of all, the owner's special expertise is seen in every room: he is a gifted master of trompe-l'oeil painting.

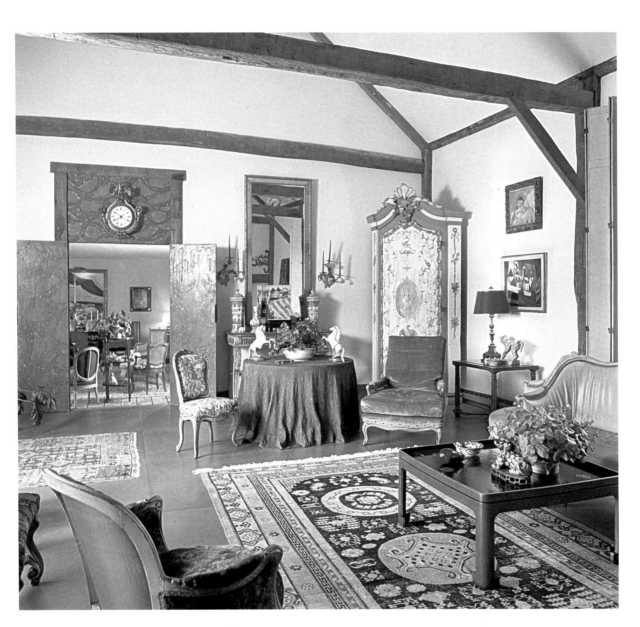

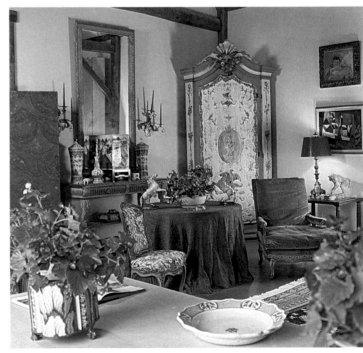

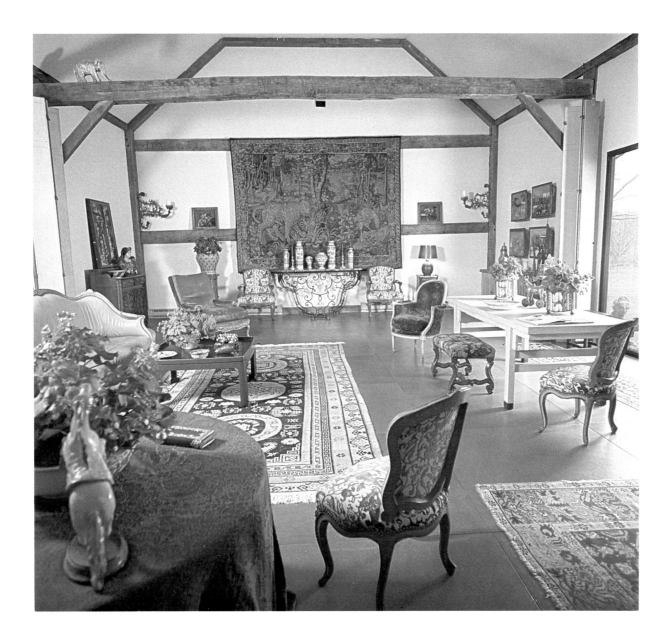

The drawing room in the grand manner is a rich mélange, reflecting the owner's wide range of interests and respect for the finest in workmanship. Original beams define the scale of the room, and the floor, which looks like polished leather, is actually made of panels of plywood painted and glazed by the owner. The Chinese, Italian, Flemish, English, and French furnishings make a splendid arrangement that looks festive and sophisticated without being formidable.

Much of the craftsmanship was fashioned and painted by the owner: the Italian corner cupboards were scraped down and restored to their original fanciful detailing; the double doors leading to the sitting room were painted from early American folk-art designs; the coffee table is a made-up version of a Japanese tray; and the cream-lacquered table opposite is copied from a Ming altar table and painted to simulate crackling.

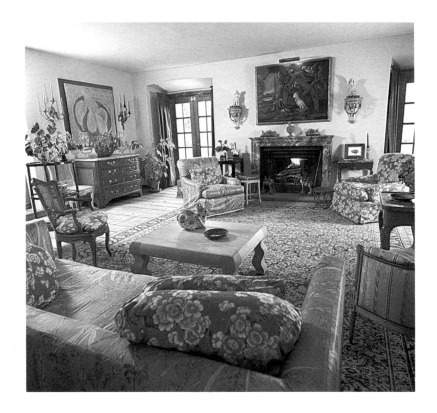

△ The sitting room is an urbane setting of warm and mellow colors that is very livable and distinguished by the owner's handiwork: the pine table with wavy legs is his own design, which has been much copied and is now a classic style in American design; the mantel is actually wood painted to resemble marble; a pair of Swedish brackets on either side were restored to their original pastel colors. The pine flooring was scraped, then bleached and left natural without any wax coating. The coral fish on the mantel, as well as many of the porcelain animals in the house, are by Friedel Schorr.

▷ The small, intimate dining room is theatrical, very dressed-up and partylike and painted to glow like a jewel. The owner's imaginative frieze around the ceiling is a painted continuation of the woven silk Chinese panel; he also painted the mantel (to look like two kinds of marble) and the plate warmer beside it (to simulate rosewood). The owner designed the fireboard of a trompe-l'oeil vase of flowers, and the floor, which is stenciled in a Chinese clouds design. The chandelier is Italian, of carved, gilded wood; the French chairs are upholstered in leather.

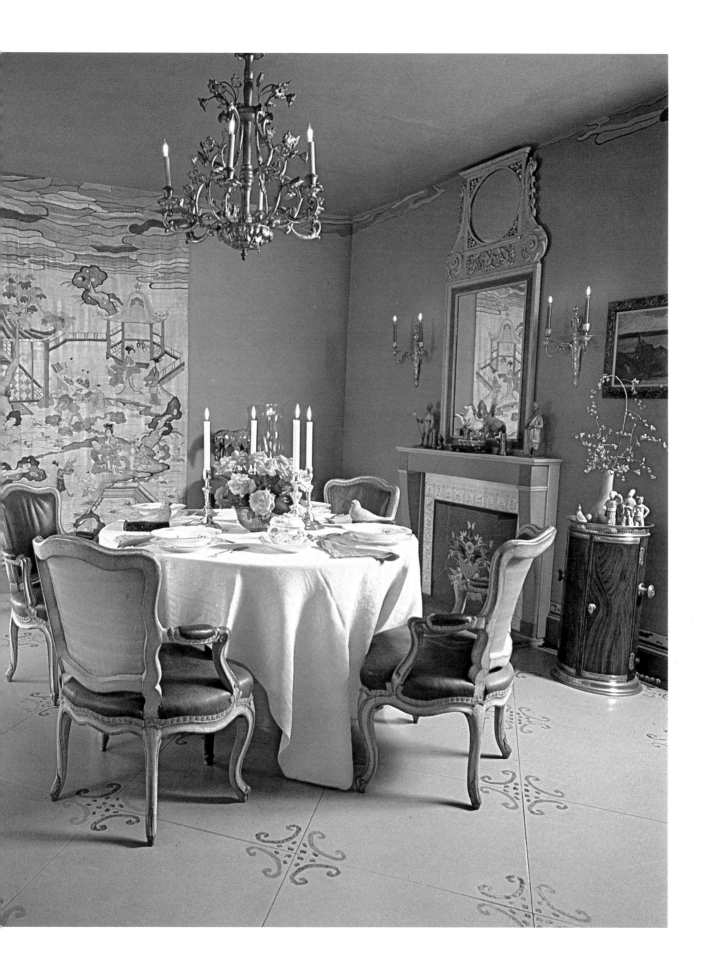

△ The simple kitchen is airy and open to nature, with the working equipment forming a U opposite the breakfast table. Two pieces of furniture show off the owner's impressive painting and designing style: the trompe-l'oeil cube cabinet at left and the combination bookshelves and dog's bed at right.

◁ For the upstairs landing, a decorative way to disguise the linen closet: the blue-and-white Delft and faïence ware is really trompe-l'oeil painting (there are even luscious-looking red raspberries in a bowl), so is the marble base of the French armoire as well as the plates on the wall, which are actually tin platters.

William Hodgins

THE LAUNDRY

Early in the nineteenth century elaborate summer homes housed big families and a retinue of servants to care for them. Most often the property also boasted a separate and quite humble building for washing the masses of linen they used. This modest wooden house was just such a place until the 1920s, when it was upgraded and turned into a cottage for summer-stock people. The rooms inside were small but adequate, with the downstairs consisting of three rooms: a kitchen, a dining room, and a living room; upstairs there were four bedrooms. Traditionally it became the quarters for the current leading lady or gentleman (plus their accompanying entourage) of the season's theatre offerings.

When The Laundry became a private residence, it was altered to accommodate an entertaining style with an "all-together" room tacked on to the old structure. It is a very genial idea: cooking in one part, eating in another, and the living area centered on the fireplace—the space boasts an added dimension, as the whole room opens onto a terrace and large garden.

Even with the expansive new room it is still a nice little house in the sense that it is uncomplicated and unpretentious. The owner is partial to patinas of old woods, especially pine, and to a mix of English and American country antiques. Everything is useful and used, comfortably settled together with a discerning eye for straightforward, clean-line designs.

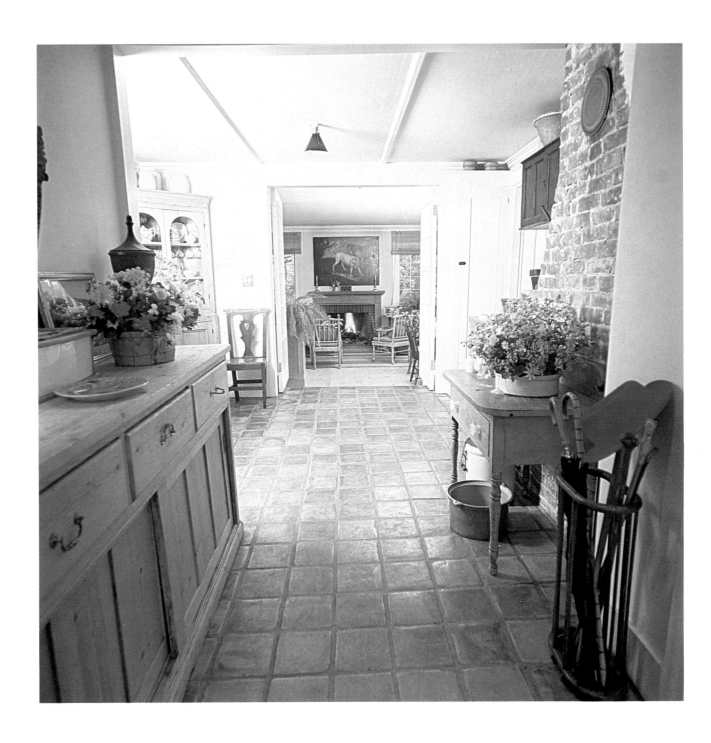

The front hall and entranceway are a visual delight, with a melding together of sand and earth tones in wood and stone textures. To the left is a pine sideboard (inside is the stereo equipment); to the right a nineteenth-century American painted table. The length of terra-cotta tiles sweeps directly to the new addition: two steps go down to a twenty-foot-square space with an open kitchen, dining area, and sitting room.

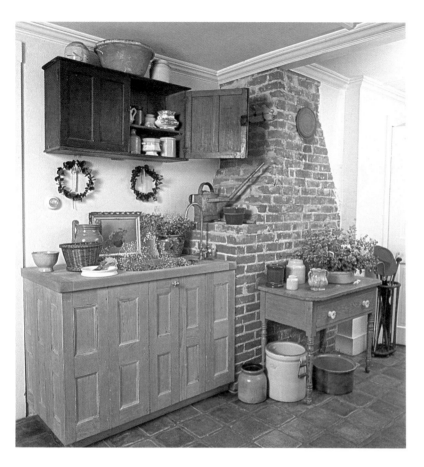

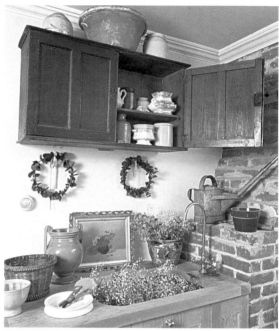

△ A collection of jars, bowls, jugs; potteries of cream-ware, earthenware, and stoneware are all inspirations for doing flowers. The cabinet is an early American painted piece. The wreaths, used as a base for fresh vines, are dried eucalyptus leaves. Arranging flowers (or serving drinks) is made easier with a wet sink hidden in a made-up cabinet of pine shutters topped with a butcher block. The exposed brick chimney is the fireplace structure for the bedroom on the other side of the wall.

◁ The way the furnishings are put together shows the owner's love of fine craftsmanship and simple materials. An English corner cupboard of pine is handy for the best china and table linens. More storage space is in the antique, wicker steamer trunk. A big, painted tin tub holds black-eyed Susans that grow in wild abundance around the house.

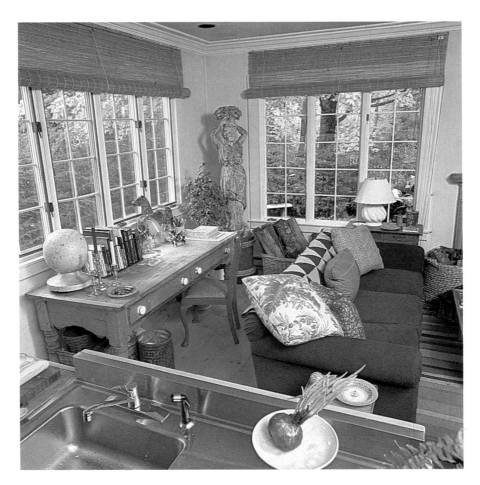

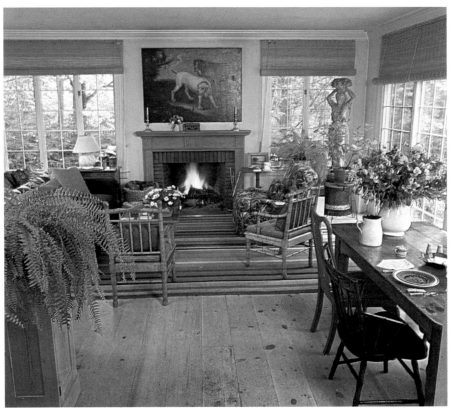

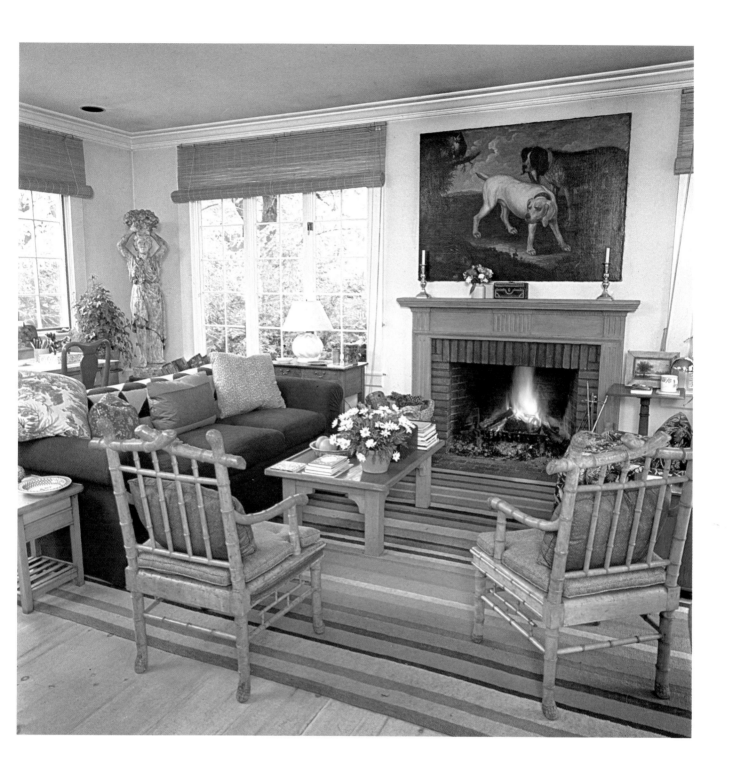

Honeyed tones of bamboo and pine give a mellow glow to the sitting room that opens onto three exposures to take full advantage of daylight. Instead of heavy curtains, the natural blinds make the room more airy and informal. The look of the room is a cosmopolitan mix with a homey result.

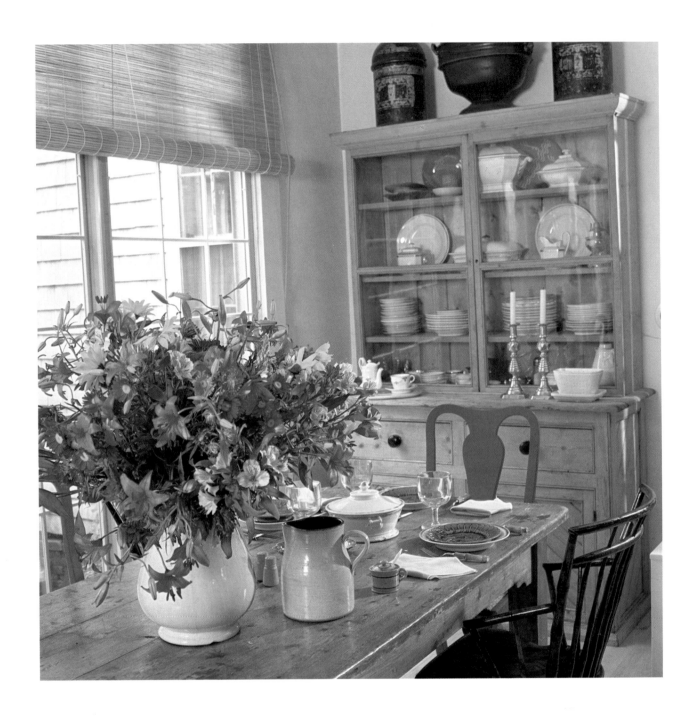

△ Directly opposite the kitchen, overlooking the terrace and garden, is the dining area. A generous glass-fronted cupboard holds the everyday china and tableware. The china pattern is white with a gold rim, called Wedding Ring. A nineteenth-century birdcage Windsor chair sits alongside coral-painted chairs that are modern copies of the Queen Anne style. This view of the new room addition is from the fireplace wall looking through the front hall.

▷ The original cast-iron stove has been in the house since it was a working laundry, and it is still used. The kitchen is a simple L shape with a food cupboard behind the louvered door.

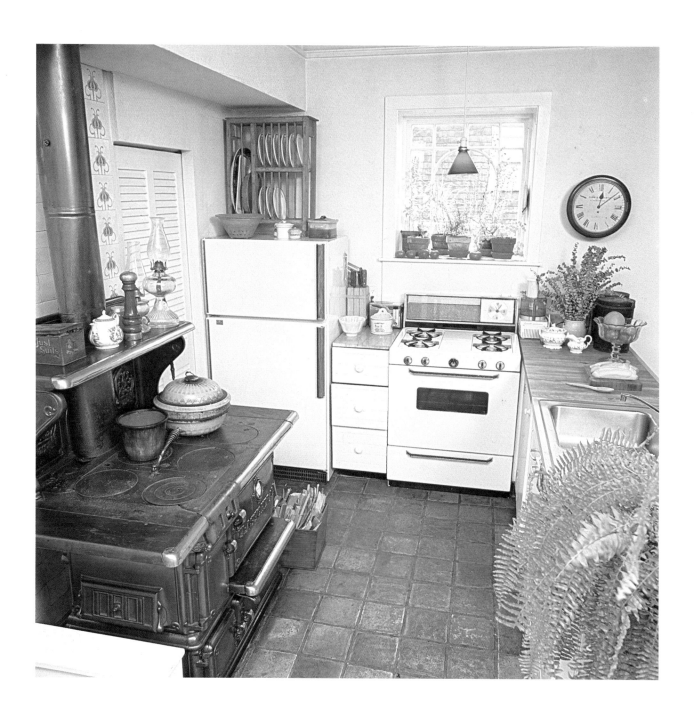

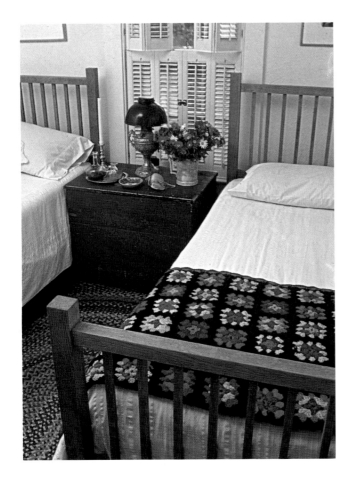

△ A bedroom just big enough for two beds and an armoire has the charm of a vignette painting. Crocheted afghans on the Mission oak beds, an old, painted blanket chest for the bedside table, and a braided rug give color and texture to the tiny space.

▷ Every inch of space is used in the little house: here, a place for jugs and crocks is found over the door at the top of the stairs. The ginger bottles, marmalade jars, and tobacco humidors are all used for flowers. The neo-Gothic side chair upholstered in a thistle pattern is English.

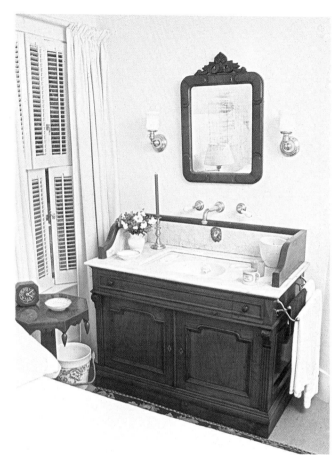

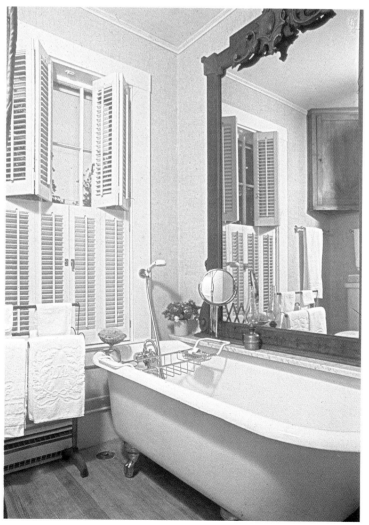

△ A Victorian washstand of mahogany is as decorative as it is useful in a bedroom that manages to have all the amenities without any clutter. The walls are textured stucco; the floor is covered wall-to-wall with sisal matting; and the teardrop mahogany table beside the bed is English.

◁ To enlarge a tiny bath, a carved Eastlake mirror dominates one wall. A pine cabinet is tucked into the opposite corner. The old tub is given a special treatment: the feet have been brass-plated. The flooring is pine, rubbed with white gesso and varnished; and the creamy walls are covered with a linenlike fabric.

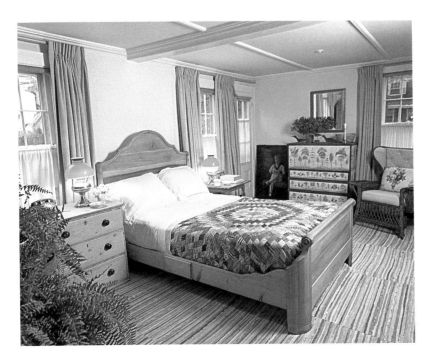

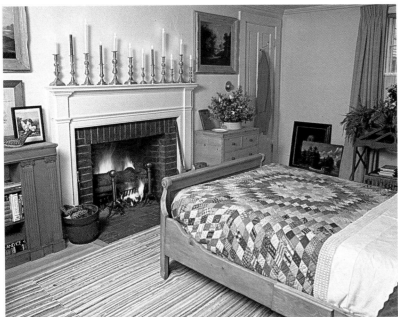

What was once the living room is now a very comfortable bedroom with the original fireplace and mantel. The pine sleigh bed is made up with heirloom linen sheets; the patchwork quilt is a Building Blocks design. The rag rug in pottery colors is handwoven. The early nineteenth-century blanket chest painted with a design of trees by Robert Jackson is a copy of a famous American antique.

The mantel shows off a collection of brass candlesticks. The pine bookcase is a fine piece of carving, with fluted columns and capitals. In front of the window is a copy of an English plant stand that has been crafted and spatter-painted by Yorke Kennedy.

Richard Neas

POKY HALL

According to the owner Poky Hall was one of the plainest, tackiest, pokiest little houses ever built in the 1930s. The plan was square and boxy, the rooms and windows were small, and the only redeeming thing about it was the very choice seaside location. Fortunately, the house was perched high enough to command a wide-angled view that seems to unfold in tiers below the property—the lawn falls away to sand dunes, which then stretch into a wide flat beach and the ocean.

Because of the way it was built the little house paid no attention to the spectacular view. To remedy the situation the front door was moved around to the driveway side, partitions were knocked down inside, and to take further advantage of the scene two porches were added, one on top of the other, traveling the length of the house. Now every room (except the kitchen) has a view of the water.

The nucleus is a big center room (21'x 30') with a fireplace. In decorating it, the owner disregarded the idea of sand and sea and the simple life that most associate with cotton duck slipcovers and wicker furniture. (The only concession to easy care is a painted floor that can be mopped clean.) The rest is a cosmopolitan assemblage of antiques and beautifully constructed, upholstered furniture done in silk and velvet, chintz and leather. Accessories and pictures are carefully arranged to enhance the worldly atmosphere—it is a natural blending of colors and shapes done with an artist's touch and flair for design.

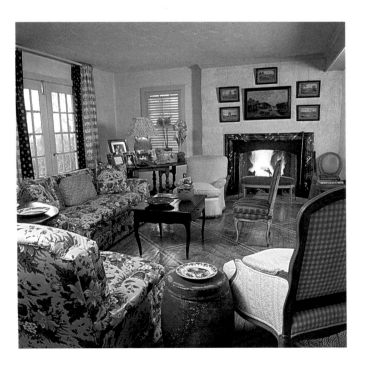

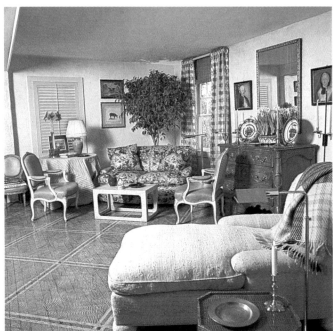

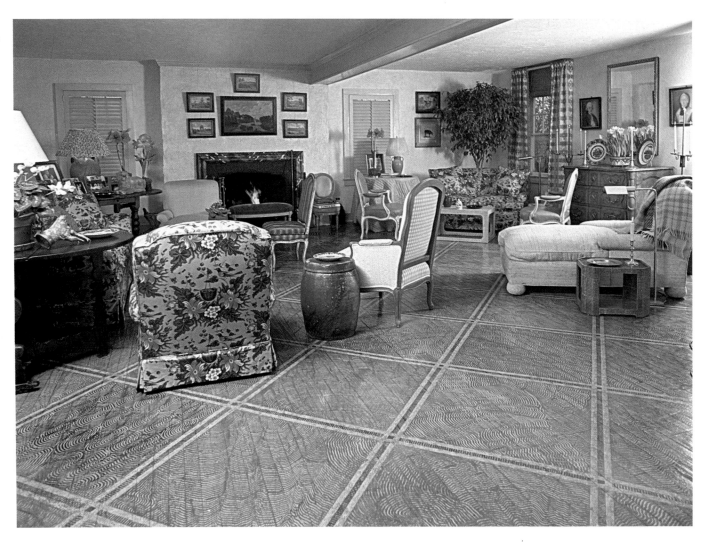

◁ The big downstairs room faces the ocean with three glass double doors that once partitioned the space inside. The owner created the unifying floor pattern by comb-painting it a lively green; the walls were rough-plastered, then glazed by him in a soft honey tone. The effect is a warm expanse of comfort, mellowed with an old documentary chintz pattern copied by Brunschwig & Fils together with an interesting mix of formal and country French and American antiques.

▽ Set in a niche off the living room, the dining table is just opposite the fireplace and reflects the same decorative spirit of warmth and soft color seen throughout the house. The antique chairs are English and American; the gate-leg oak table is modern; and the painted cupboard is an eighteenth-century Pennsylvania piece.

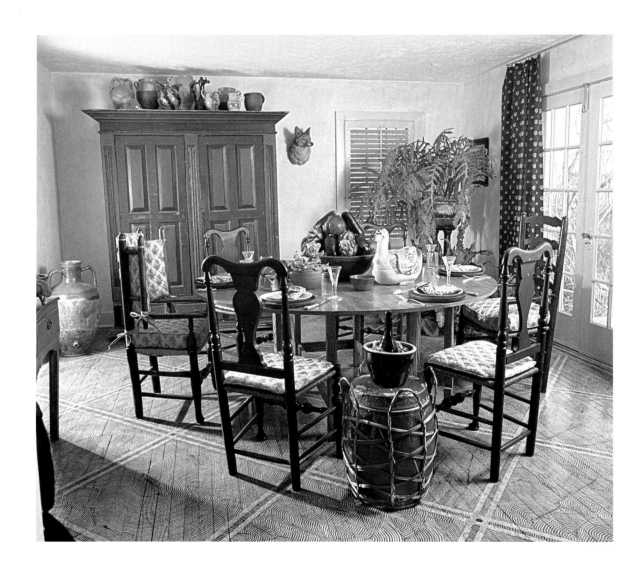

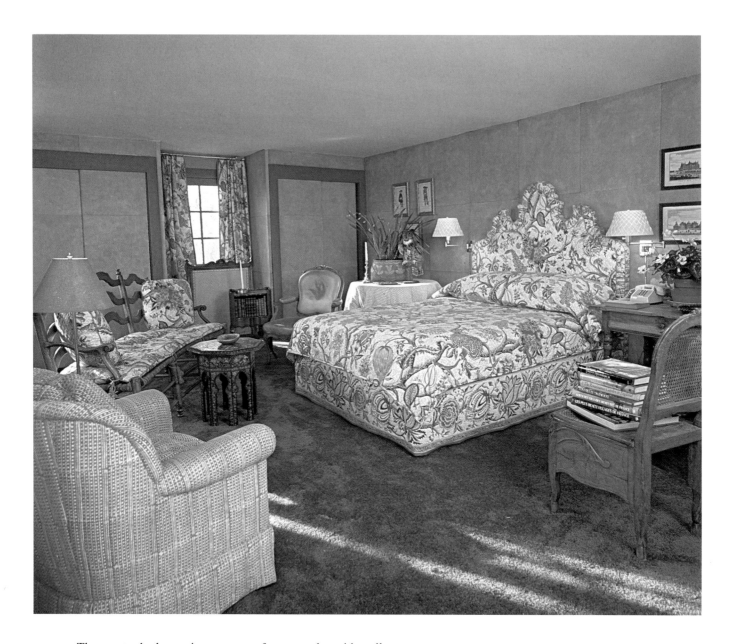

The master bedroom is a cocoon of tawny color with walls
painted by the owner to simulate leather squares. The furni-
ture, again, is a melding of periods and styles, but some of
the things that seem to harmonize so well are quite disparate
in origin and design: a little Hindu table used for picnics
stands in front of an important Louis XIV painted bench; a
stenciled Indian basket shares the table with a stuffed owl
and sits near a sophisticated Louis XV leather armchair. The
rest of the room is pulled together with a flamboyant chintz
echoing the owner's favorite color combination of but-
terscotch and raspberry. This, too, is a documentary pattern
reproduced by Brunschwig & Fils. Attention to detail and
handwork are the other elements that make the decoration so
attractive here: the headboard is hand-quilted with an edging
of ruching; and on either side the lampshades are handwoven
of paper in a basketweave design that allows small diamonds
of light to shine through.

John Rosselli

ROSEHILL
AND FOLLY

In the late 1850s Italianate villas were at the height of their vogue. The style of architecture was pleasant and rather grand, but not at all overwhelming, with surprisingly modern floor plans of open rooms widened with generous bay windows. Perhaps because the style was so accommodating and so reminiscent of their European background, the Rosselli family built just such a house in the 1880s in the middle of their farm—at that time their land covered about 900 acres of pastures.

A century later, Rosehill still sits high on a hill overlooking barns, a duck pond, a dove house, and a chicken coop turned into a "Folly" for guests and parties. The youngest son (the last of fourteen children) kept the villa for his own home and renovated the inside with modern baths and a new kitchen. The mood is still the same, sociable and informal, with rambling rooms, soaring ceilings, and windows filled with plants, but the decoration is highly ornamental, utterly flamboyant, and unconventional. It is a house dominated by wondrous displays of blue-and-white porcelains in every conceivable shape and form. The assortment is dazzling, as is the dramatic mix of interestingly shaped furniture and boldly patterned rugs.

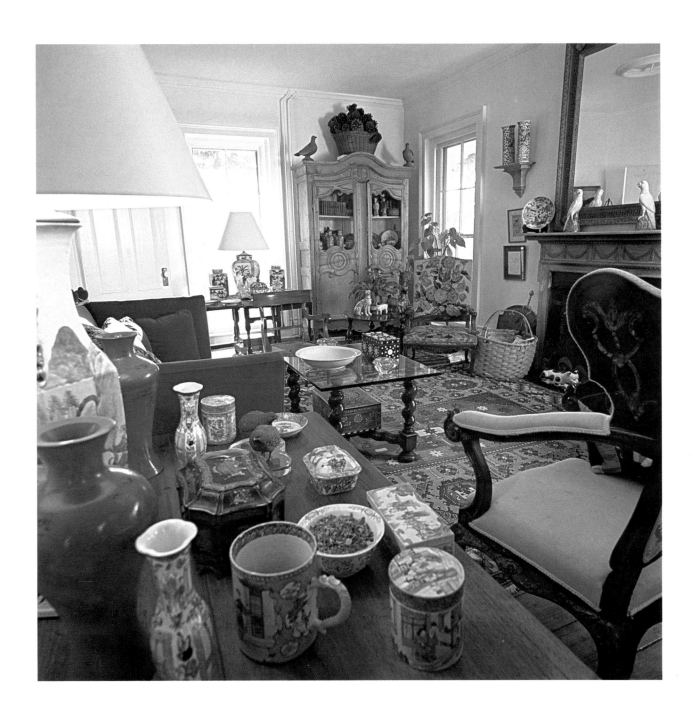

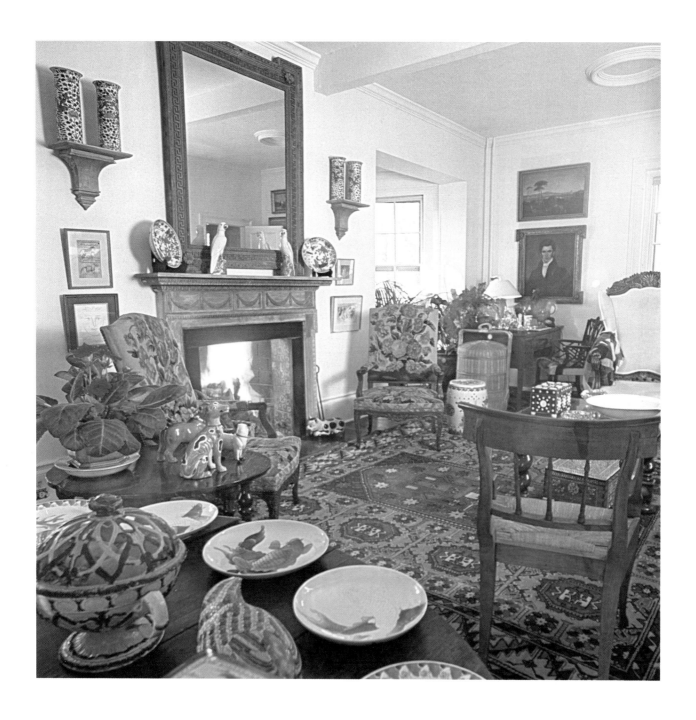

A combination of exotic elements personifies the owner's
taste for unique things and his flair for arranging them. The
atmosphere is artful and vigorous, a designing adventure,
distinguished by a collection of Canton porcelains, Italian,
Portuguese, and English furniture, and a fine Turkoman rug.

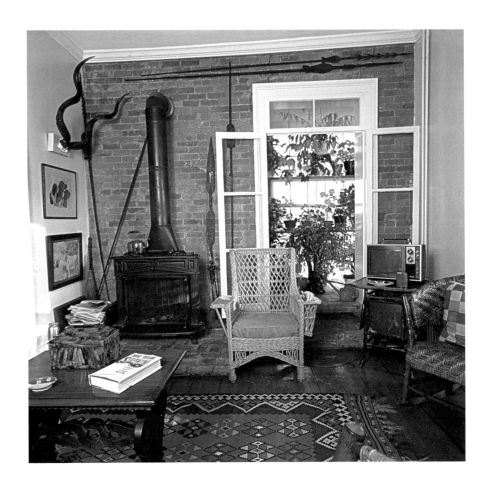

Unlikely, but perfectly homey looking, a set of Adirondack furniture settles around a cast-iron stove in the cozy sitting room off the dining room. The small coffee table is eighteenth-century Italian, the yellow-lacquered wicker chair is Bar Harbor style; the rug is Middle Eastern.

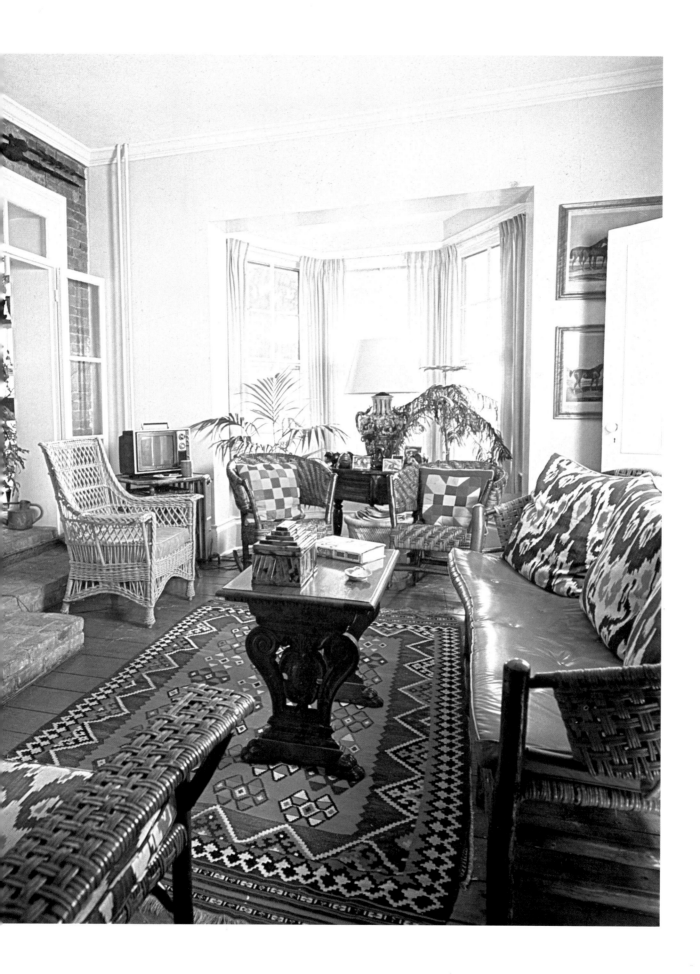

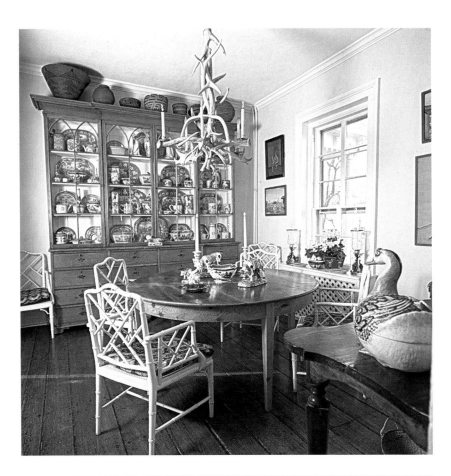

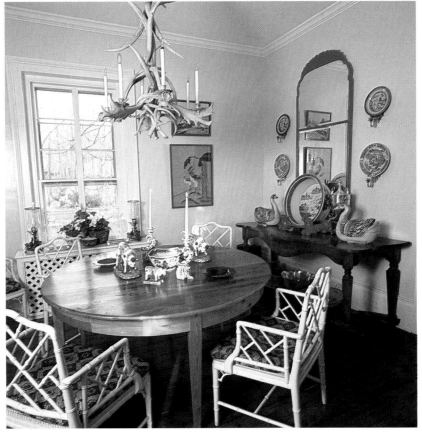

Blue-and-white porcelain comprises the largest as well as the oldest group of Chinese export wares made for the West. When shown to best advantage, it is grouped in a mass, as it is here in an English breakfront. The horn chandelier is antique Austrian; the pine table was made by the owner from old closet doors taken from an eighteenth-century house when it was demolished. In the corner a Dutch Queen Anne lacquered mirror is paired with more export ware and an Italian eighteenth-century table.

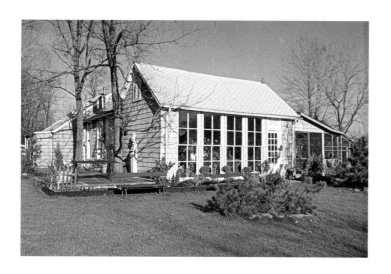

Folly

The chicken coop is a composite building with old pine beams, Victorian windows, barn siding, Dutch doors—all elements taken from buildings on the family property and from other houses demolished in the nearby village. The owner, working as his own architect, dreamed up the commodious scheme of the place as he went along, letting the "finds" guide the dimensions. The result is exotic, a greenhouse of fragrant blooms and cages of cooing doves, with Oriental, Islamic, American, and European furnishings shown off with wit and grandiose sprawl. The owner's collection of blue-and-white porcelains is arranged like a library of books, stacked on wall-to-wall, ceiling-to-floor shelves with all the available table space given to the overflow.

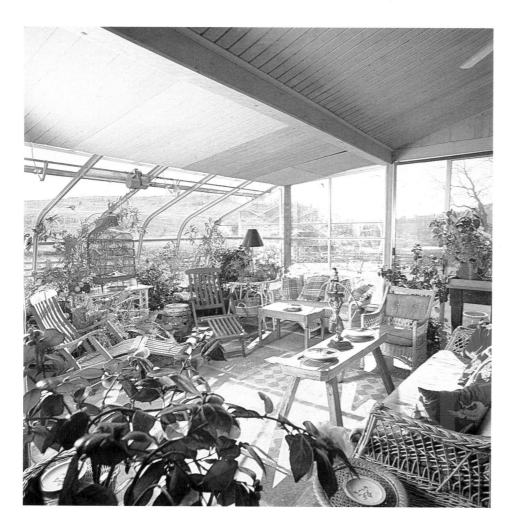

Orange and lemon trees, geraniums and petunias, camellias and oleanders, in flower all year long make a perpetual summer in the greenhouse room. Everything is gardenlike and outdoorsy with wicker furniture and Cunard Line deck chairs. (One is labeled *Queen Mary*, the other is from the *Queen Elizabeth*.)

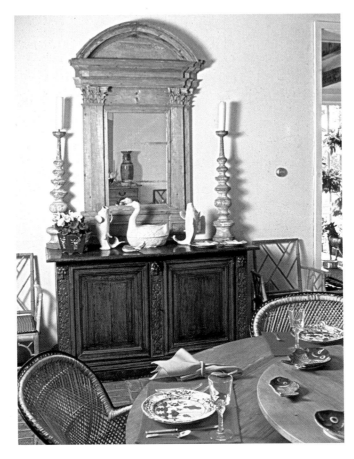

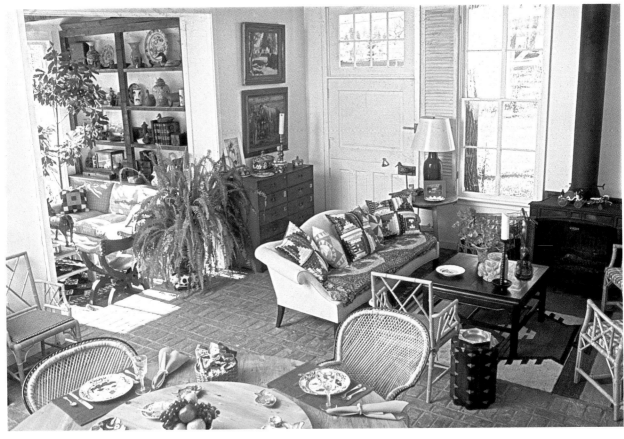

◁ The spacious dining room-sitting room is a step up from the open kitchen and has a brick floor, beamed ceiling, and floor-to-ceiling shutters at the windows. The furnishings show an international mix: to the left is a seventeenth-century carved-oak sideboard paired with an eighteenth-century Italian mirror of pine; the side chairs are Chinese Chippendale bamboo; and those around the table are of Buri wicker. Just beyond is the sitting area, which is centered with a cast-iron stove.

▽ The tidy kitchen is made up of cutting boards for counters and cabinets made of rough barn siding and bleached pine; supplies are kept behind the shutter doors opposite the island sink. The big dining room beyond is centered with a round oak table (diam. 7′) designed by the owner with a Lazy Susan top.

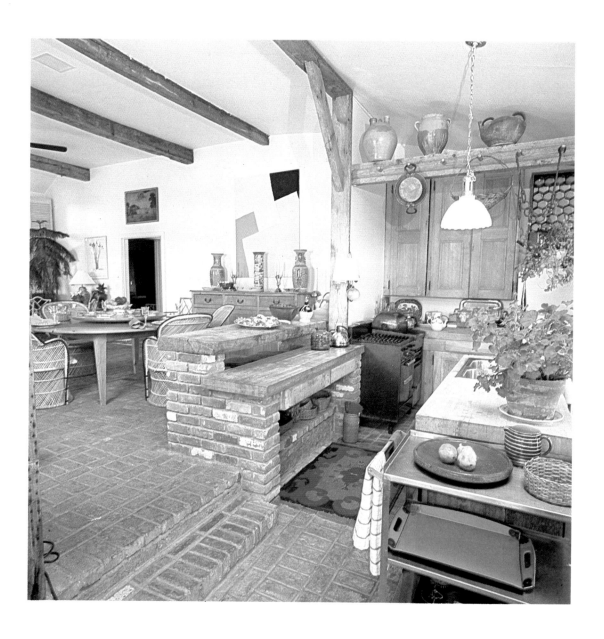

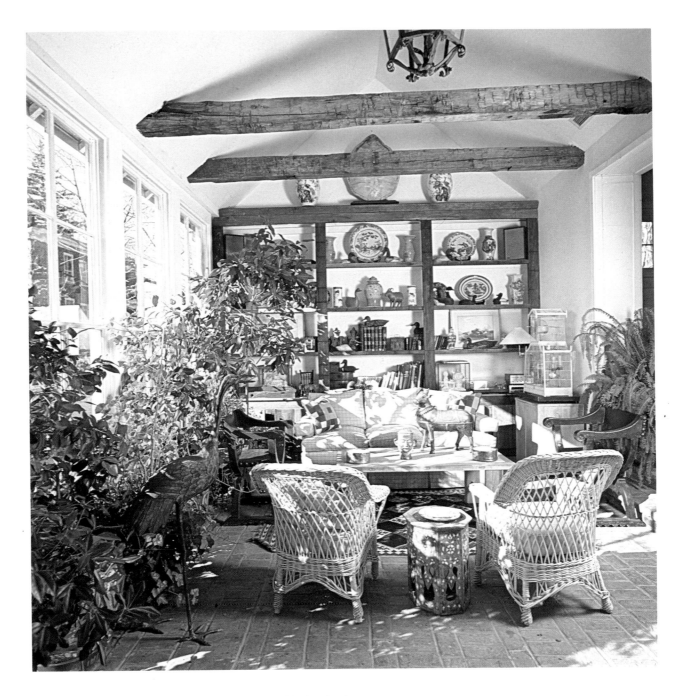

The main sitting room of Folly has a feeling of widening horizons:
the ceiling is pitched high and long windows catch all the brilliant
light. There are no doors—space flows from there to the green-
house room and the dining room–kitchen, both of which are on
different levels. Floors throughout are brick and sandstone. Here, a
comfortable sofa is the nucleus for sitting—natural wicker pieces
have cushions of buff cotton suedecloth; the Italian Renaissance
chairs are leather-covered. Peering over the foliage on the left is a
Japanese bronze crane; an eighteenth-century brass bull on the
coffee table is Indian; the brass ashtrays were Chinese spittoons.
The blue-and-white china on the shelves mixes with all sorts of
favored objects: a bleached tortoise shell, straw animals, wooden
decoys, pictures, and books.

Eleanore Kennedy
KILKARE

Some years ago a for-sale ad appeared in *New York Magazine*: "A gift from the sea … in need of moving and repair, this magnificent and unusual house can be bought on three acres of prime oceanfront. If you have imagination, money, and an eye for a bargain…."

The house was 100 years old and massively Victorian, but the structure was meant to last. It had been built by a crew of ship and dock workers with forty-foot beams, engineered to withstand a storm as well as any seaworthy vessel. The whole shell of the house, supported and made stalwart with a forest of locust-wood posts, set the frame up like a ferry in its slip, securely propped and anchored.

The sad part of the story was the inside, where layers and layers of old paint covered moldings, windows, and floors; ceilings everywhere were falling down; but worse than that, there was a basement kitchen with nothing but brick ovens for cooking. In the renovation all the wood throughout was painstakingly stripped down to its natural state, and a new ground-floor kitchen was installed next to the dining room.

The house is now a barefoot, low maintenance kind of place, meant purely for summer living, with bare windows and floors, slipcovers of cotton canvas, and decorative accessories that are "found," like seashells and driftwood sculptures. For heating, there are nine fireplaces; for night-lighting, there are the original hanging lamps from 1879, plus ceramic-shell wall sconces supplemented with lots of white candles in crystal holders. As for pictures, there are sixty-four windows overlooking magnificent sea views.

To carry through the consistency of design, the same ceiling idea is used in every room of the house: cherrywood moldings patterned to make geometric shapes, with each room having a different pattern. To restore the moldings, the owners made a diagram of each ceiling, took down the wooden pieces, stripped and varnished each one, then replaced them all on a white wallboard backing. (Originally there had been straw matting between the moldings.) The look throughout is of a uniformness of natural wood tones sharpened with all-white walls. Outside the same natural tones prevail, with the concrete foundation hidden beneath horizontal redwood planking weathered to blend with the shingles.

Essentially, the restoration was one of paring down to basics to liven and brighten up a fusty old structure. With decoration and embellishment kept strictly to a minimum, the remarkable character and strength of the house are allowed to shine through with great dignity.

 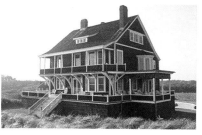 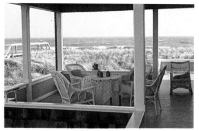

▽ Beginning in the front hall, the expanse of natural pine floors, cherrywood moldings, and white walls go all through the house, giving a continuity of design that's as refreshing as it is original. The furniture is minimal: the eighteenth-century French armoire doubles as a coat closet; a lacquered upright piano along with airy plants keep the entranceway breezy looking. The portrait over the fireplace is an oil painting of the owner by David Croland.

▷ The sitting room defines summer living; being free of clutter, and decorated with found ornaments from the sea, easy-care fabrics, and mobile furniture. The crescent-shaped banquette designed by the owner can move close to the fireplace for a small group of people or be pushed back for a big party. The Victorian picnic chairs are fold-ups that go where needed; the small plastic tables are on rollers.

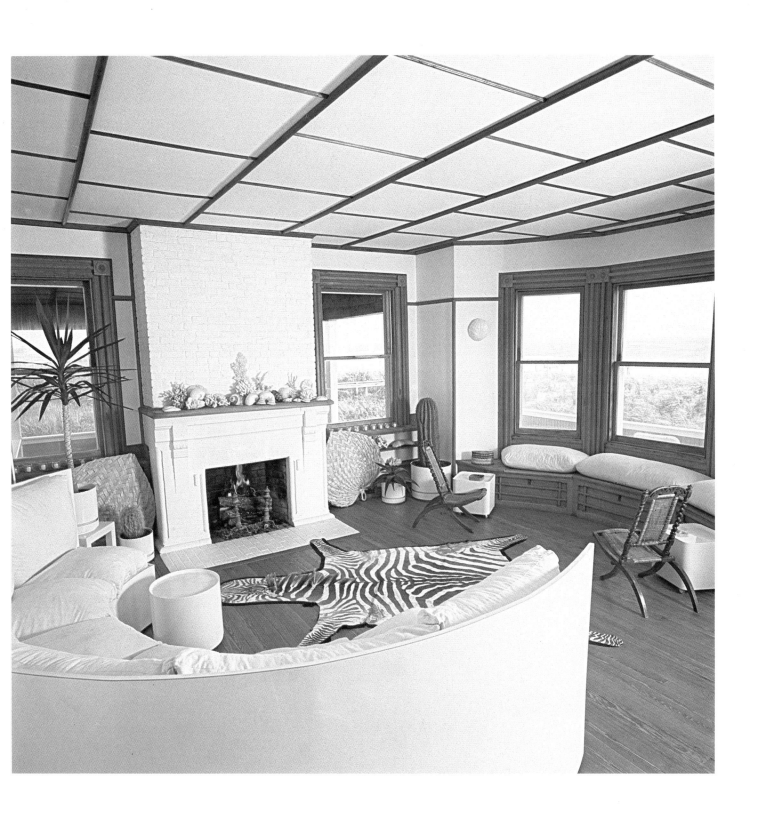

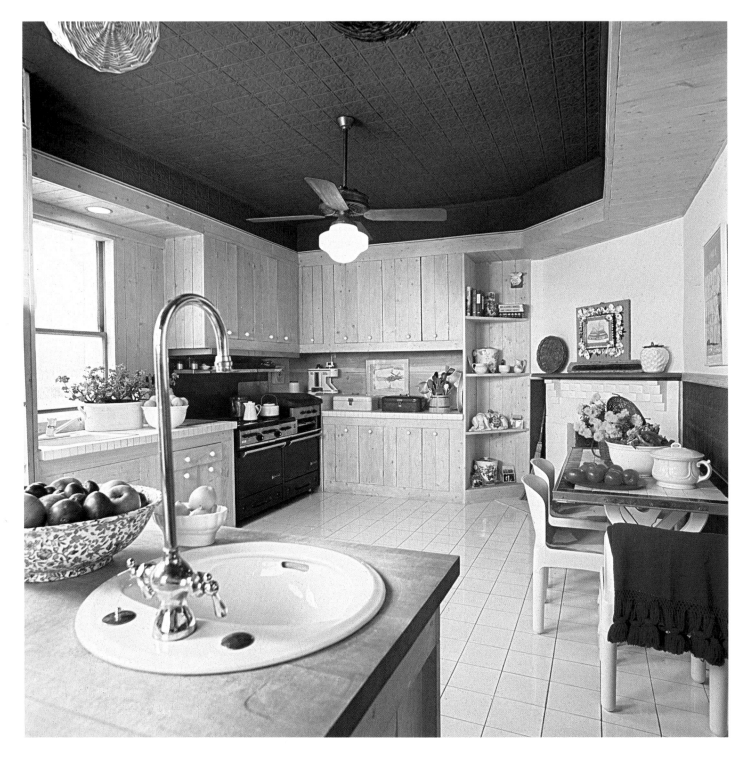

Once a bedroom, the kitchen designed by the owner is functional as well as inviting and easily works for serious cooking as well as entertaining. The ceiling is pressed tin, which was widely used in Victorian days; the floor is made of white ceramic tiles; the cabinets are gesso-washed poplar. In the foreground is a butcher-block island containing the sink, storage space, dishwasher, and even a trash chute to the basement. The old dumbwaiter that once went to the original kitchen in the basement is now a storage place for wine.

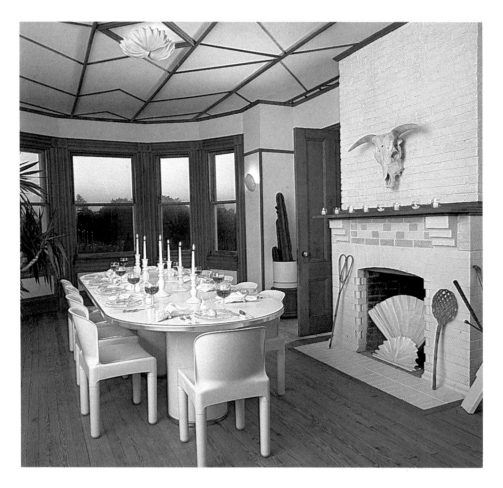

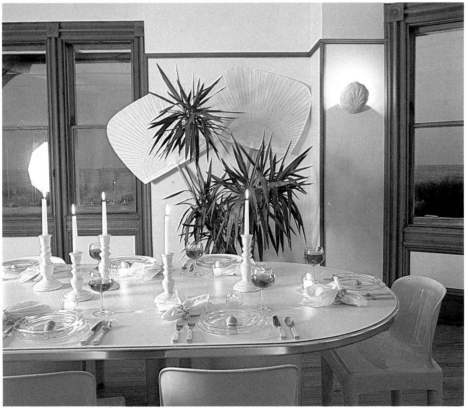

◁ The dining room, warmed by a luminous night glow and dozens of candles, is meant to be colored with vivid people and pretty food. The chairs are molded plastic that do for outdoors as well as in; the table is a washable white laminate. A controlled lighting system with dimmers is hidden behind the ceramic shell sculptures on ceiling and walls. They were designed by the potter Martine Vermeulen. The pristine whiteness of the table is set off by silver and gleaming crystal. The napkin holders are tiny shells strung together in a circle; larger shells with names written on them make place cards.

▽ The stairwell climbs up from the front hall to the bedrooms with an impressive view to the east. In order to light the landing, the shipbuilders constructed a massive ship's knee, which contains the thrust of the bay window and makes a pleasant circular corner for watching the sea or having a cup of tea.

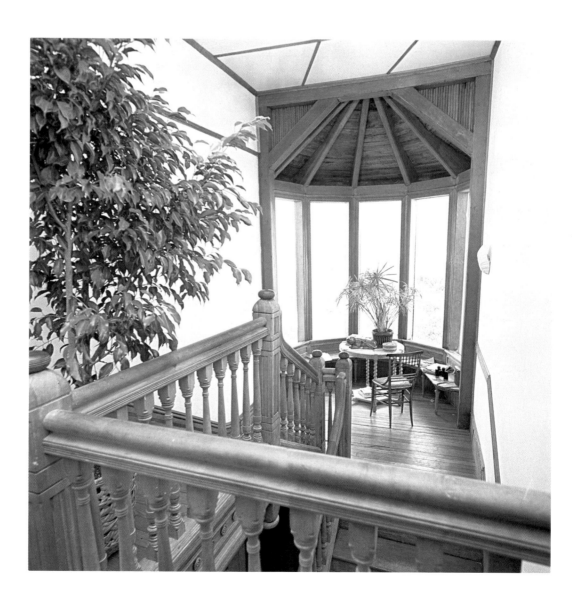

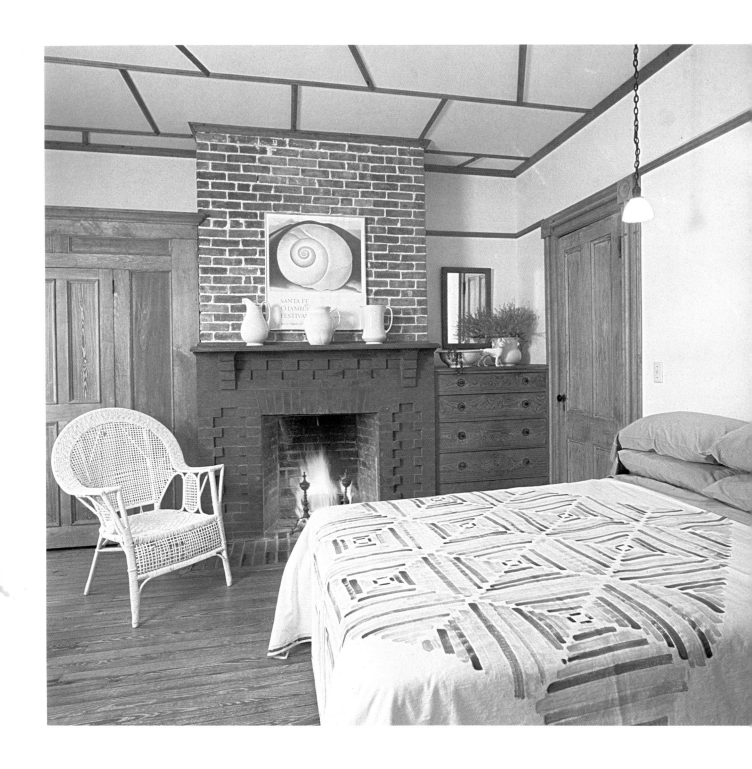

Textures and patterns give life to a small bedroom, one of the
few rooms in the house with a built-in cupboard and chest of
drawers. Earthy colors with sea blues and strong doses of
white keep the feeling clean and crisp. The hand-painted bed
coverlet is by Peter Fasano.

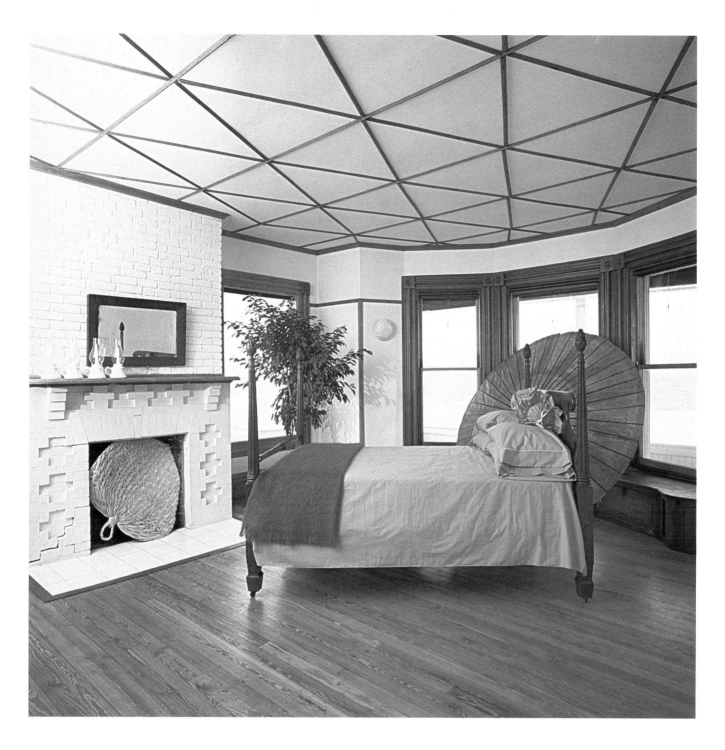

In the guest room furnishings are minimal to keep the space open and serene. A four-poster bed floats in the center of a polished oak floor; the red-lacquered Japanese umbrella is a color whimsy that is meant to hide a baby's crib. The windows are bare, with green roller shades to keep out the early morning light; and at night, white torchère lamps and plastic stack tables on wheels roll up to the bed for convenience. The outdoors is accentuated in the color of the sheets: a periwinkle–lavender-blue, very much like the shade of a summer dusk.

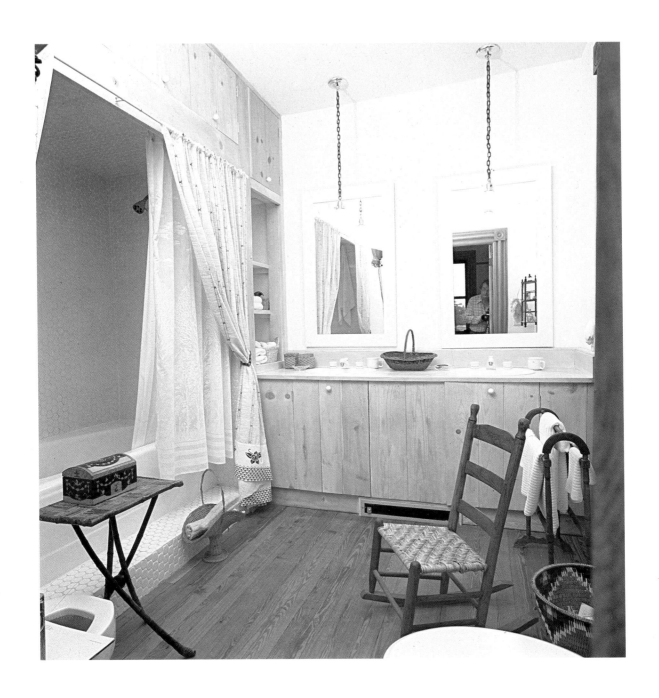

The bathroom is done in all natural tones, with bleached-pine cabinets, a pumpkin pine floor, baskets for soaps and sponges. The child's ladder-back rocking chair was found in the attic.

Robert Jackson
MILL RACE HOUSE

A tumbledown shabby house that nobody wanted had been standing since 1895, but the place had never seen good times since the day it was built. The structure was just a shack, and of the meanest kind, with no plumbing or electricity. There were flimsy cardboard walls, a ladder going to the upper story, and a kerosine stove for cooking. There were no amenities whatsoever, and to add to the decay the rooms were filled with decades of trash and empty gin bottles.

To the new owner Mill Race house was a bargain for two reasons: the land was beautiful and the Hudson River Valley view was breathtaking. He even saw possibilities in the primitive shack, and decided to renovate it rather than tear it down. The basics were done first, then the front porch was enclosed and turned into a kitchen; the little downstairs bedroom became the dining room with proper stairs going up to the two bedrooms. And to save on fuel, two Jøtul woodburning stoves were installed in the downstairs rooms. By keeping it small, the house is now manageable and undemanding.

Without having to fill big spaces (and without a jumble of things), the decoration expresses a distinct attitude: it is rather a painterly approach, showing a keen sense of order and a judicious use of color and form. The furnishings are pared down to a few special pieces, and nothing is imposing. It is a style that is economical, in the sense that what matters, matters; and the rest is edited out by an eye trained to see rooms as pictures.

The dining room has a panoramic view (the one within as well as the one outside the window) done by the owner in the eighteenth-century style. The walls are vivid scenes of mountains, lakes, waterfalls, trees, red barns, and haystacks, a sort of lyric painting to bring the outside in. The pine stairs are bleached white; the floor is stippled dark green. With the mural surround encompassing the whole room, there is no need for any other decoration.

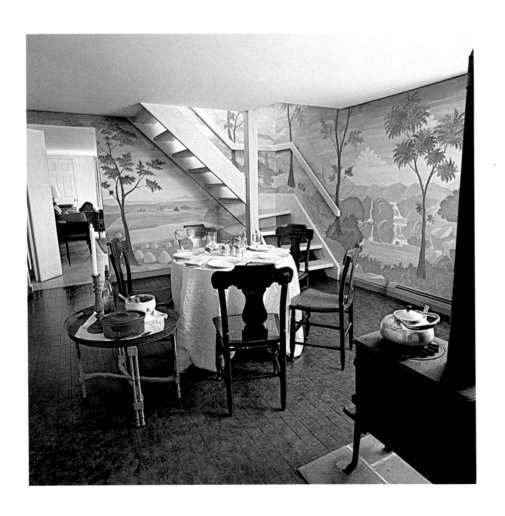

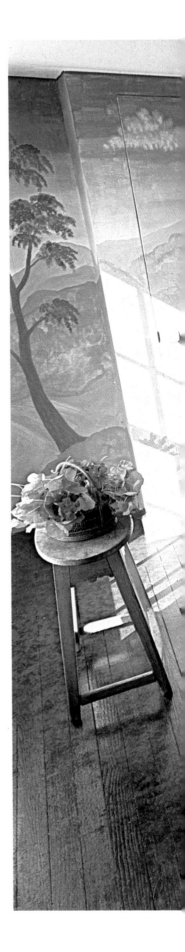

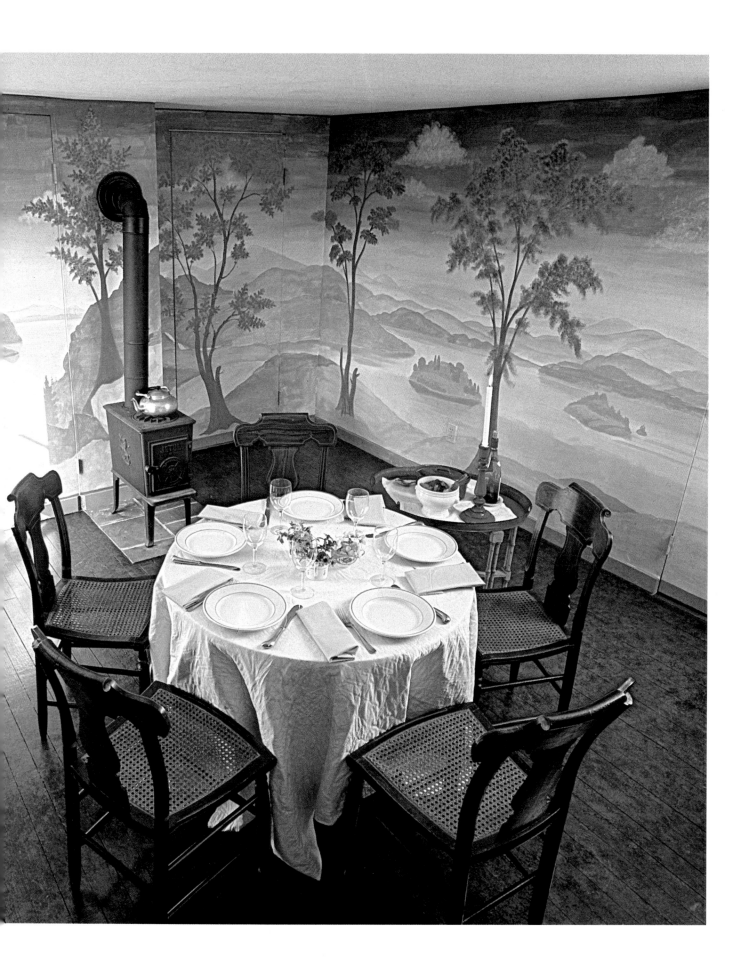

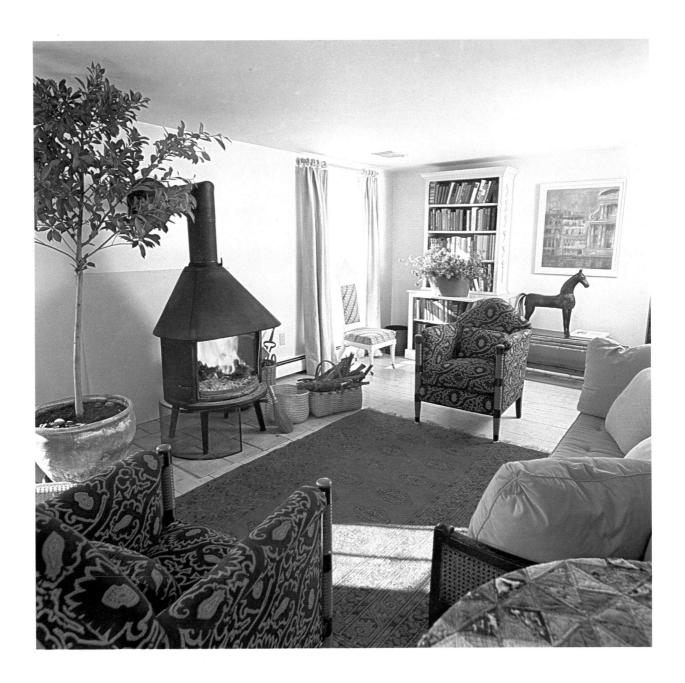

With regard to light versus dark tones, the living room shows
a composition of color and mass in careful balance. The
strong shape of the Norwegian stove is tempered by equally
strong-lined chairs covered in a French provincial print. The
sofa is Regency, of caning and black-painted wood; a reclin-
ing deck chair is also of caning. All the furniture, being the
same height (and with the legs showing), gives an eye-level
evenness to the room and to the raised fireplace. The
bleached floor is painted with a light graining design by the
owner. The rich red rug is a Bokhara.

Galen Brand
HOYT HOUSE

The town's oldest house, a historic one on the main street of the village, is really three houses rambled together into one: the original part began as a 1767 saltbox; add-ons and roof-raising started in 1870; and a separate apartment (for a house-within-a-house) was devised by the owner in the 1970s.

For all its sprawl and winding ways, the Hoyt House still shelters the summery-fresh cottage look of band-box prettiness and apple-pie order. The decorating hallmarks are purely feminine: flowers in many figurations, with chintzes blooming all through the house; highly glazed majolica earthenware everywhere, often hung on the walls in place of paintings; and old-fashioned ruffled curtains of white organdy or cotton eyelet. The colors are soft and clear, the furniture is affectionately put together, and wandering through the rooms is like looking at a treasured scrapbook of fond remembrances. The message is uncomplicated and happy and reflects the spirit of the house, which has had a reputation for generations as a lively, entertaining place. The Hoyt family were musicians and actors, who used to stage theatricals and concerts at home, making their house a cultural center for the whole village.

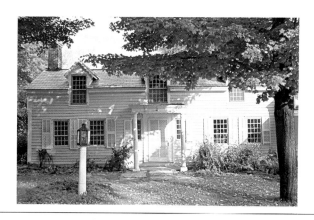

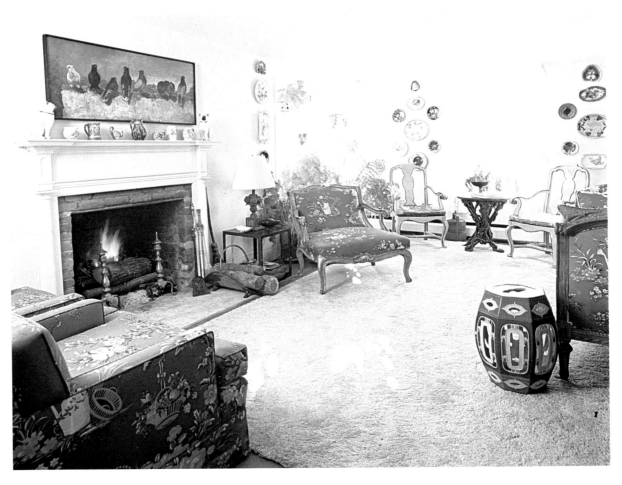

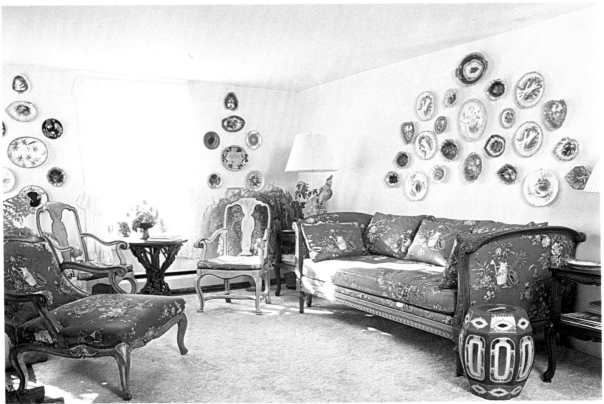

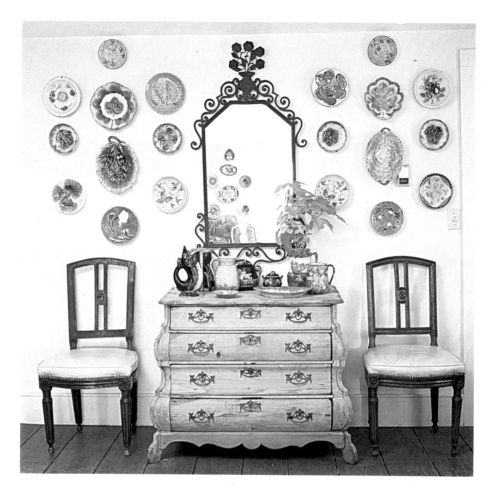

◁ Bouquets of flowers in a pretty chintz and a fascinating collection of majolicaware work well together to give the living room an utterly refreshing and feminine air. The furniture, which is Italian, was acquired by the owner in her years of living abroad and looks very much at home in the lighthearted room.

△ A corner of the living room makes a vignette wall for showing off the brilliantly glazed majolica earthenware that so appealed to the Victorians—patterned in cabbage leaves, cornstalks, twining vines, and basketweaves, the stylized designs add depth and gleam to the room. The pine chest is Dutch; the chairs and the mirror are Italian.

▷ An extended window niche to the right of the fireplace is a wonderfully sunny spot for lunch or afternoon tea. Even on the bleakest winter days a greenhouse atmosphere prevails with garden-fresh collection of flowering plants and lacy ferns.

The library walls are patterned in the eighteenth-century manner with a delicate hand-stenciling of pale peonies and bluejays—a happy camouflage for the original marred surfaces. When the old wallpaper was removed, there were places that needed patching; to hide the damage, stencil expert Adele Bishop antiqued the walls with flat varnish mixed with raw umber and then stenciled the garlands and birds on top. The light stenciling warms the room without overwhelming it and works well as a pleasant background for the softly patterned rug and the antique quilt.

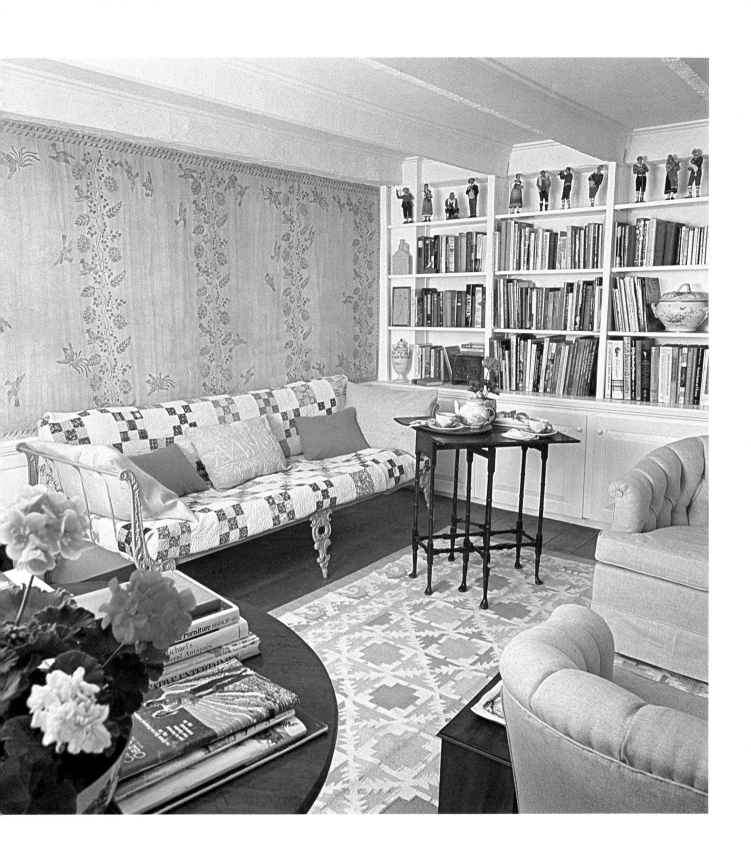

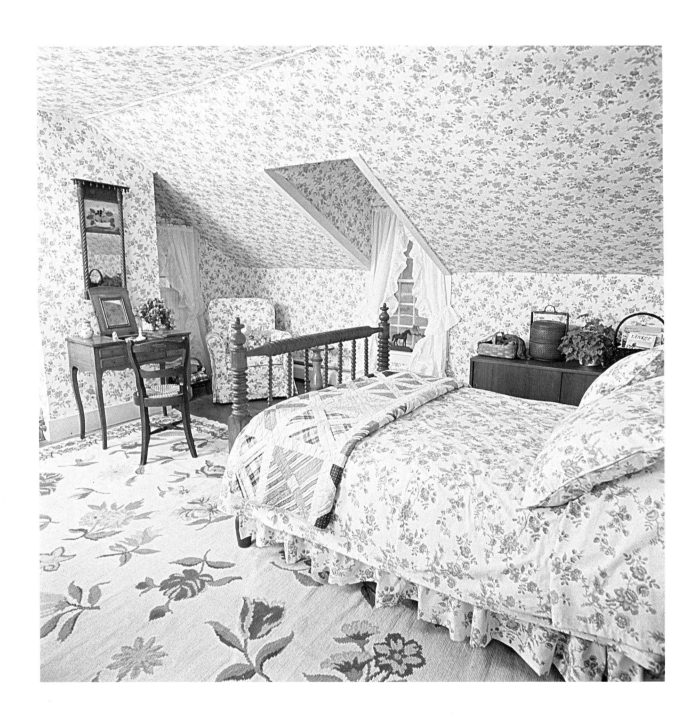

The dormer bedroom is lined like a nineteenth-century chest in a sprigged floral print that touches everything with a cheerful flourish. The Italian chairs are fine companions for the American spool bed, the Federal period mirror, and the French dressing table. A small anteroom that serves as a dressing space is freshened with lots of white and leafy green plants filtering the sunlight. The tiny greenhouse in front of the window is Victorian. The iron animals are all antique doorstops.

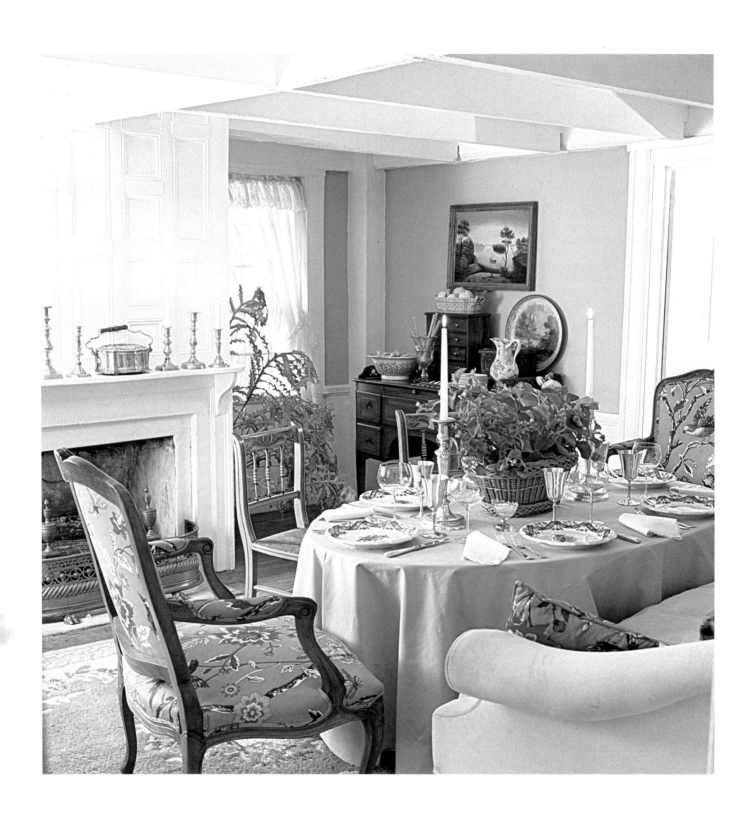

The dining room washed in clear robin's-egg blue is gay with
chintz and a bright patterned rug. The genial seating arrange-
ment has a big sofa doubling as a banquette and French
armchairs pulled up around the skirted table.

Mari Watts

UPPER FARM

Built in the late eighteenth century on one of the oldest farms in the county, the house has always been a beloved place, with the same family living there for almost a hundred years. When the Watts acquired the property in the 1950s, they moved the little house away from the main road and down the hill to its present site. (In the photograph the object in the foreground is a birdhouse that is a clay replica of Upper Farm modeled by the artist Condict F. Hyde.)

The best time of day to see Upper Farm is at dusk during the winter, just when the lights go on and the whole house glows with warmth. The setting makes a pretty picture, to come upon it after a winding drive through the fields down into a shallow valley, with the place looking as welcoming as a log fire, it seems far away in time, sunk into the deep countryside, and overlooking a natural preserve. The pond (which was once a bog) attracts the migrating ducks and geese that come and go in season, and even wild deer wander nearby.

Inside, the house opens up like a child's paint box of fresh color—clear yellows, sharp greens, and reds flow through rooms that show an affinity for such Victoriana as tufted chairs, needlepoint window valances, beaded pillows, and shadow-box pictures. It has all the handmade charms of the era and none of the stuffy fustiness. The style is highly romantic, fused with elegant furniture and an admirable instinct for making rooms friendly and fun to be in. It's as gay as the owner's lively paintings, which are seen throughout the house; in fact, the entire house is a charming invitation to come to the party.

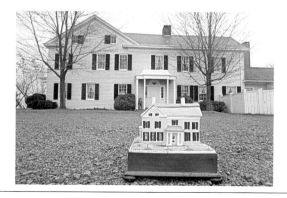

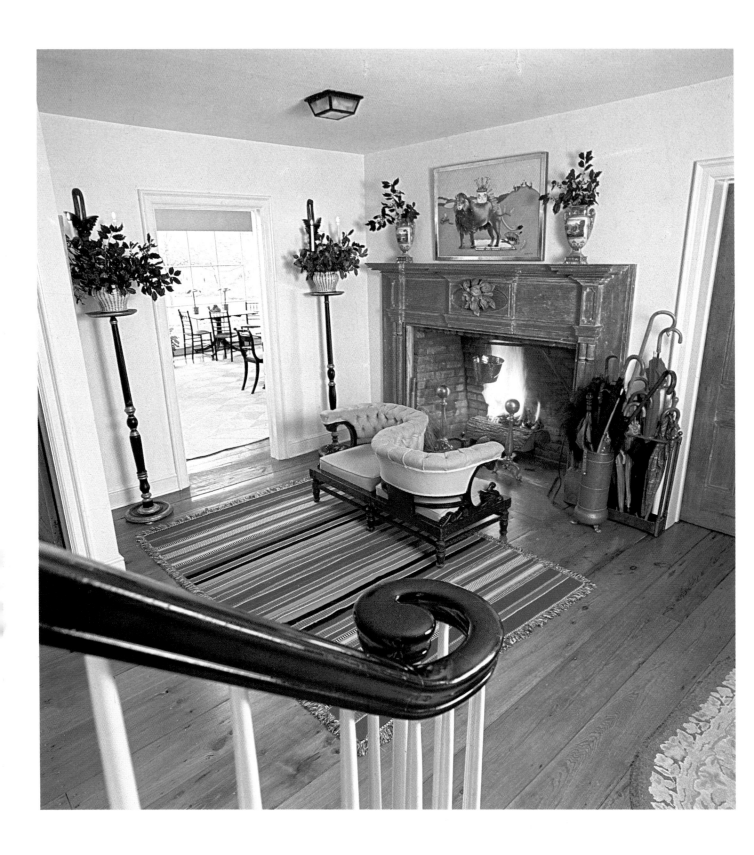

◁ The front hall is as welcoming as the rich blaze of the fire, with the Victorian tête-à-tête placed just so for warming. The striped rug is Portuguese; the carved candelabra are Regency. The painting over the pine mantel is by E. B. Watts, daughter of the owners.

▽ A warm palette of convivial reds and yellows prove the point that related shades can draw diverse elements together. The Victorian tufted chairs in spicy red satin mix easily with the modest cotton slipcovers, and the intricate needlepoint valances of rose garlands blend well with simple curtains. Comfort and color are the keys here, with small family paintings, Victorian artworks, and lots of majolica, Staffordshire, and Meissen china grouped together on tabletops.

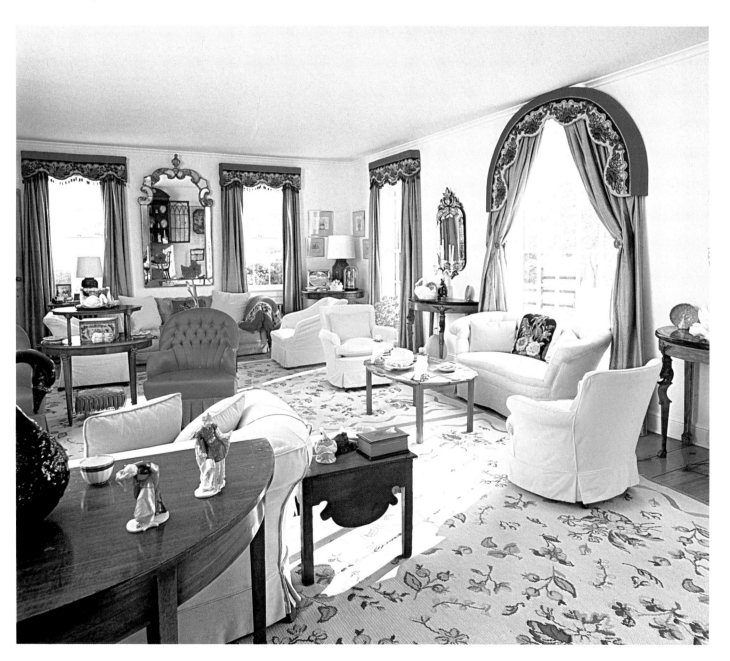

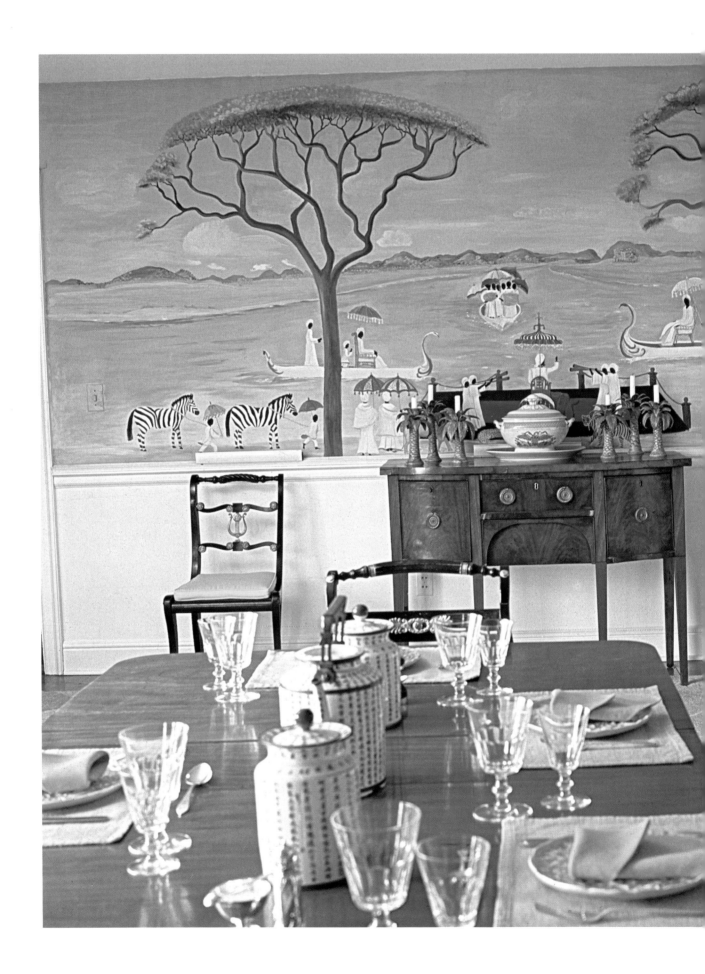

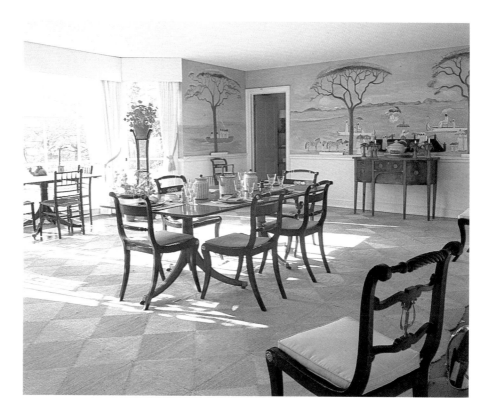

The dining room is a pure fantasy painted by the owner: a scenic wraparound of the Blue Nile meeting the White Nile. The walls are covered with white-robed Egyptians, fanciful camels, zebras, and elephants, and feathery acacia trees brush the ceiling. The natural straw rug and crisp white curtains keep the light, airy quality of the room.

A small cozy bedroom is splashed with big dollops of bright red to give a festive look. The rugs are Romanian; the chintz is English; the curtains are made of wool flannel. The pillow in the wing chair is Victorian, a combination of beadwork, needlepoint, and stumpwork. A hand-painted screen by the owner makes a pretty corner setting to hide a closet door. The scene is a composite of the village's main street.

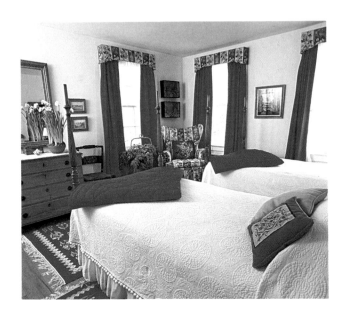

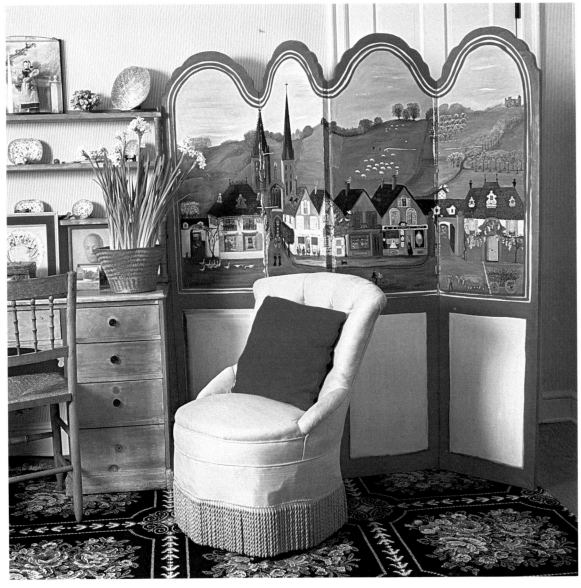

Charles Morris Mount
MEMORY LANE

Meant for lots of good food, music, and fun, this is an entertaining house for people to enjoy without formalities. It has a feast of furnishings, a magpie abundance of found objects from the local antiques shops and flea markets, all looking as cheerful as a candystore's wares. The ambiance is a special one that shows off a bounty of handmade things, mixed with lots of textures and patterns in quilts and kilims.

The place had been abandoned since 1955, but to the new owner it was made-to-order: inside the 1820s barn there were hand-pegged beams in the ceiling and a hand-planed chestnut floor; outside was a slate roof, a dry-stone wall foundation, and 150 acres of land with ponds and streams and spectacular views. The renovation he undertook opened up spaces that created three major areas: a twenty-by-forty-foot great hall, an equally large dining room (big enough for two sofas, a harpsichord, and a table that extends sixteen feet), and a loftlike bedroom. The great size allows the owner to have a lot of people in for meals and music, but the splendid design manages to keep the feeling cozy and warm. It is American country-style architecture and decoration at its best.

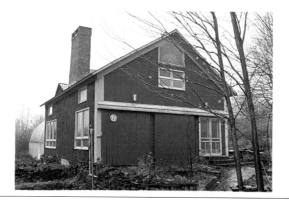

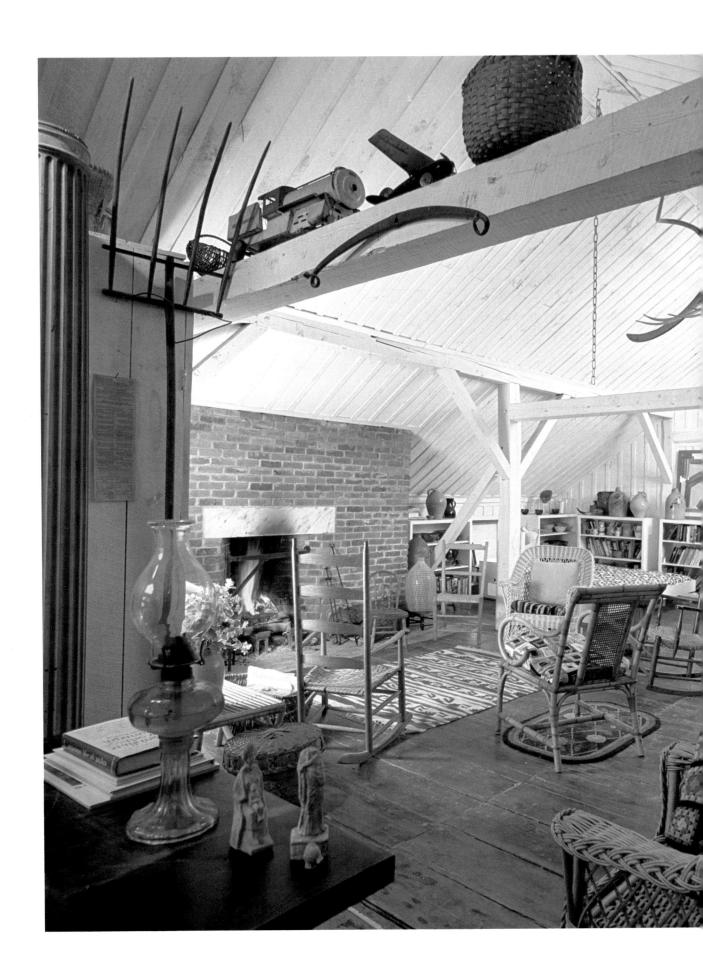

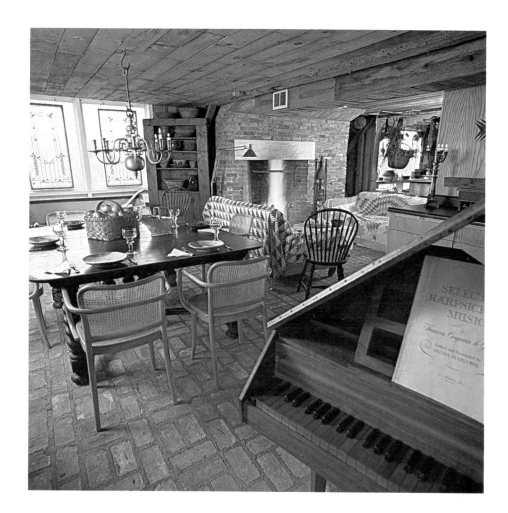

△ A dining room with expansive qualities is warmed by rough-hewn wooden boards and brick paving. The table, which can extend to sixteen feet, is a rarity called a barley twist because of its spiral legs; the chairs are Prague bentwood and cane. Quilts are used all over the house, as tablecovers, bedspreads, and pillow shams; here, they are thrown over sofas in place of slipcovers. The corner cupboard in its original milk paint displays a collection of ironstone; the brass chandelier is eighteenth-century Flemish.

◁ The lofty bedroom shows the love of country goods, expressing uncomplicated ease and simple joy in handmade things and whimsies. In the board-and-batten room there's something for everyone to admire: toys in the rafters, a barley rake hanging from the ceiling, a pitchfork posing beside a fluted column. The small stone figures in the foreground are ancient green Tanagra. Around the fireplace sits a bevy of farm rockers and chairs—an old Shaker one along with a graceful bentwood and cane armchair and a 1930s wicker style. In the far corner bookcases surround a platform bed; parallel to the fireplace is a four-poster one. The painting is by Nancy Van Deren.

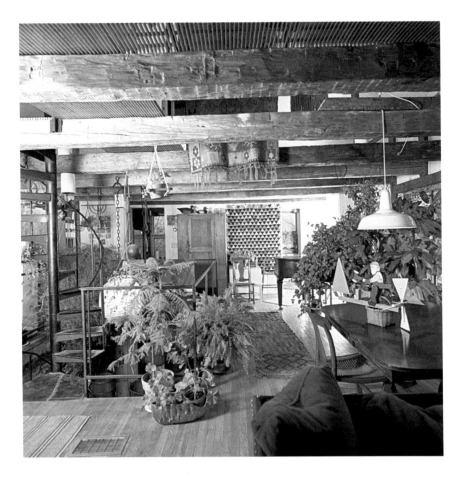

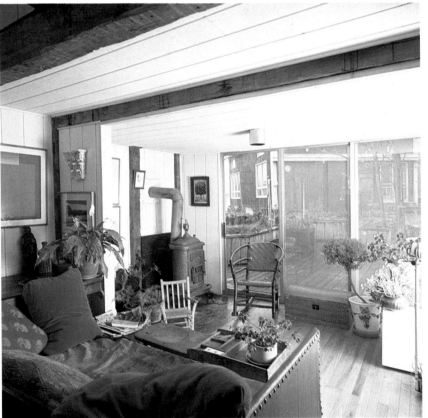

What used to be six small rooms is now the big living room, a great hall filled with plants and trees, a spiral staircase that sweeps to the rafters above and the cellar below like a flying iron sculpture. There is a sitting area by a potbellied stove in the front of the room; at the farthest end is a piano, and in between is a dining area for entertaining small groups of people. The wall hanging next to the pine cabinet is made from triangles of silk remnants.

Tim and Dagny Du Val
THE PIE FACTORY

"Living with nature" is how Tim and Dagny Du Val describe their life in a 100-year-old brick factory building. The first floor is a forest of plants and trees; the second floor houses Plant Specialists (their business firm) and their living quarters; and the roof has a picnic arbor, a potting shed, and a chicken coop containing a bantam and five hens.

To renovate what was once a pie factory and turn it into an office, a home, a forest, and a farm, the Du Vals spent two years at hard labor, both doubling as carpenters and painters. Every floor of the redone factory is an impressive achievement, but the most dramatic is the 3,500-square-foot living space. The Du Vals built in partitions to create two bedrooms with baths, and a big, square kitchen with counters that surround a center island. There are wide glass skylights, a woodburning fireplace on a raised hearth, and some ingenious decorating done mostly with plants and flowers. Furniture is sparse, and patterns arc few in order to allow the look of spring to dominate. The fresh and ever-so-healthy greenery threaded through the living room is like taking an exotic nature walk. There are twelve- and sixteen-foot-tall trees, hanging vines, little pocket gardens sprouting out of baskets and tree trunks, clusters of plants, and sweet scents from cut flowers and potpourri makings. All other colors are neutral: the walls and floors are painted white, and the cotton slipcovers are putty to match the four Himalayan cats. The joy in change and color comes with each new season's flowers and plants.

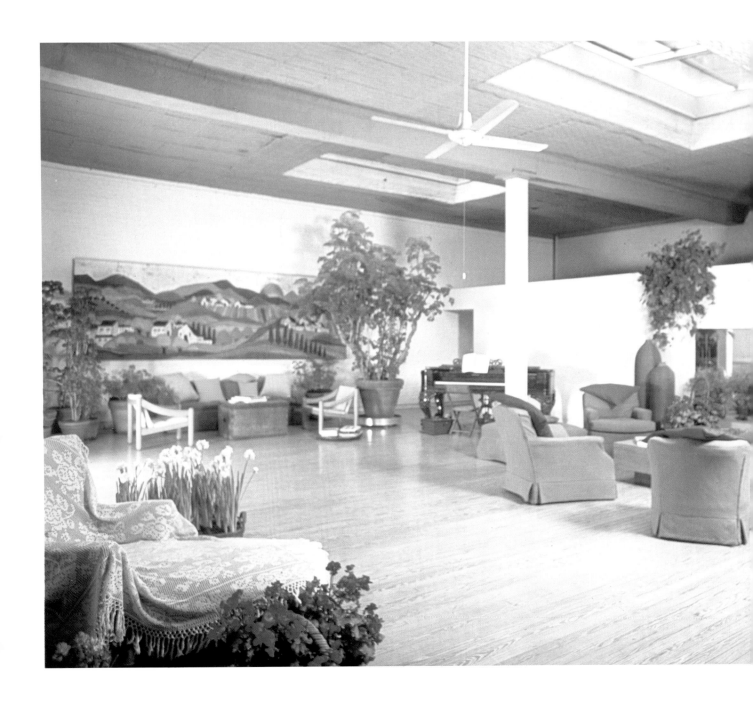

The living room has a generous and sweeping expanse. Behind the partitions are the bedrooms and baths; the rest of the space is devoted to the kitchen and areas of garden greenery for separations of space. A turn-of-the-century rosewood piano presides over the music end of the room, the quiet haven nestled between a forest of ming trees. A wall batik of rolling hills and houses is by Marlaina Deppe. The overstuffed furniture grouped around the fireplace is slip-covered in putty-colored cotton, the same shade as the cats. Bright pillows can be changed as easily as the flowers and plants to bring a different color flavor to the room.

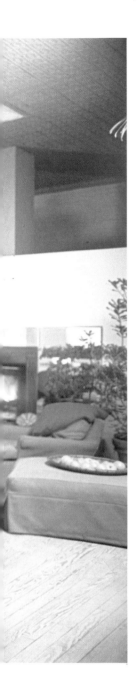

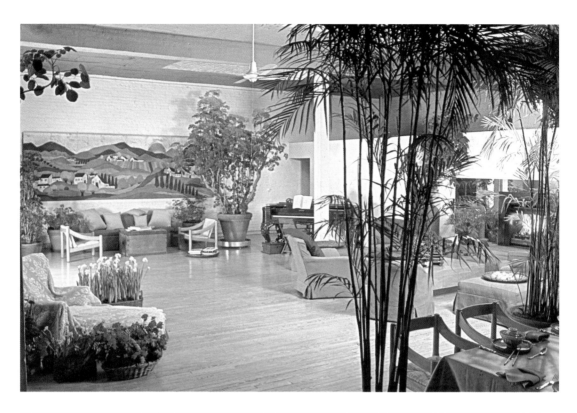

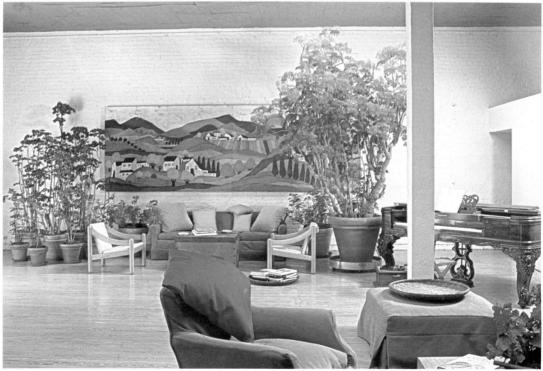

Pillars of bamboo palms cast feathery shadows over the dining table, which is set for an oriental feast. The center narcissus is clustered with Chinese vegetables; peach carnations in small bottles are at each place setting. Among the rare cycad ferns on the sideboard sits Sassafras, about to take a snooze in the salad bowl. The animal lithographs are by Deppe.

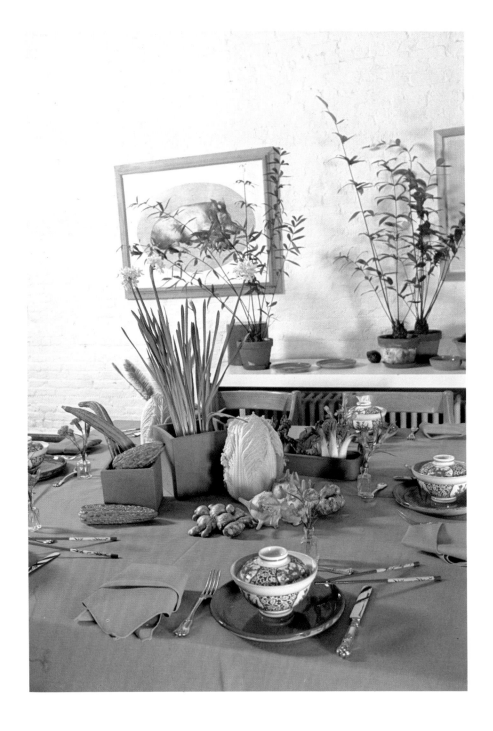

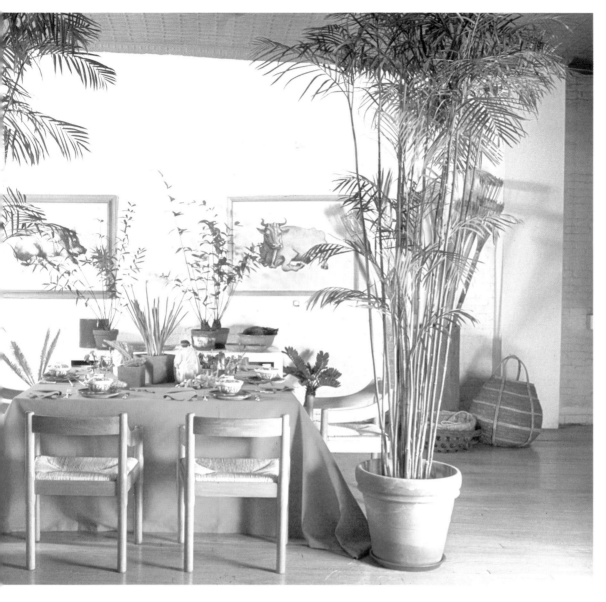

◁ Tucked under a giant skylight, a spring garden planted in baskets makes a fragrant bower for reading or resting. There are paper-whites, tulips, daffodils, hyacinths, pink quince, and irises. The tall ming tree is banked with grape ivy around its base.

▽ A wall montage of baskets, Pedro the parrot, and trays of potpourri add warmth and color to a utilitarian kitchen. The basic components are filing cabinets painted a putty color topped with white formica. There are three sinks in each ledge outlining the walls; the center island has a stove and storage. The washing machine and clothes dryer are to the right, as is the bar; wine storage is under the eating ledge in the foreground. All the formica tops are waist-high for maximum efficiency.

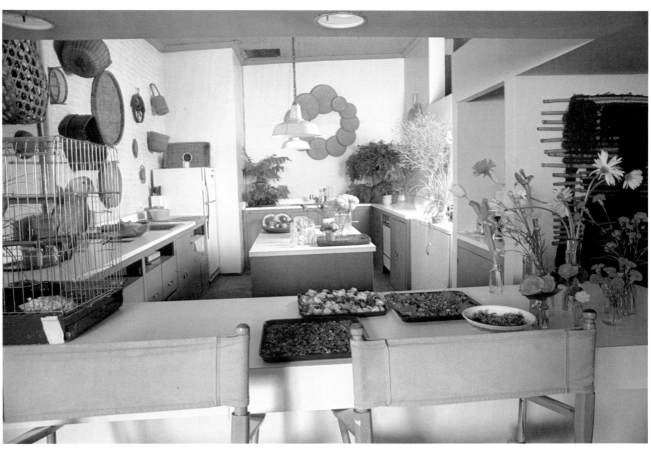

George E. Schoellkopf
HOLLISTER FARM

To a transplanted Texan who collects American antiques and art, nothing could be more suited to his life-style than a 1760s house that is an authentic New England saltbox with the classic center chimney and high-pitched roof. (The original owner, Ezekiel Hollister, who died in the War of 1812, is buried nearby.) The beautifully proportioned house, sheltered under a giant sugar maple tree and looking over a winding stream, was a jubilant find for the new owner. He had been searching for years for just the right home for his extensive collection.

The house was not only structurally original (the old clapboards are still on the front) it was also in top condition, with most of the floors and some of the windows left intact. Fortunately it had been saved from disintegration about thirty years before and lovingly restored. The wood thoughout the functional, spacious rooms is white pine; there are four fireplaces, handsome paneling, built-in corner cupboards, and windows facing all exposures.

With the perfect place for the perfect furniture acquired, the owner just moved right in, happy to be surrounded at last with the right atmosphere. His decoration was a matter of showing his furniture to best advantage. The excellent pieces are country and country formal, not elaborate or heavily carved. Their smooth surfaces and simple lines bring a pleasantly restful quality to the rooms. Everything is placed with a strict regard for scale and fitness, and the result is a harmony of art and architecture that comes off well, without looking stilted or too serious. The owner calls it "plain vanilla," but the house has the special charm of making the eighteenth century seem positively delightful and adaptable to today's living.

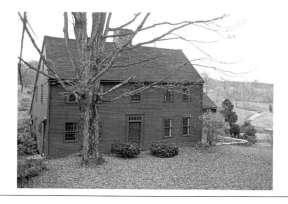

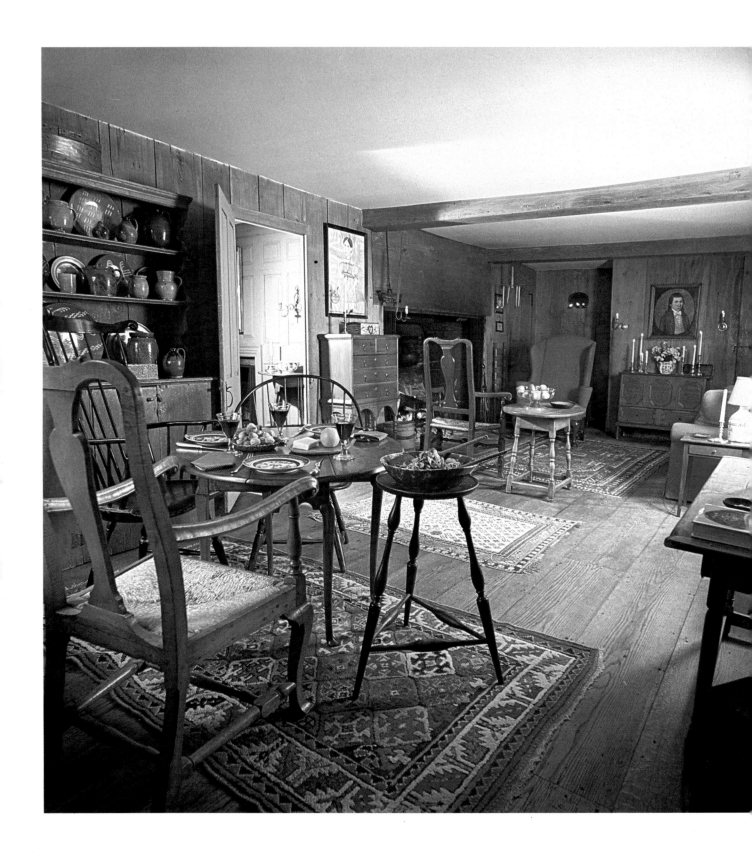

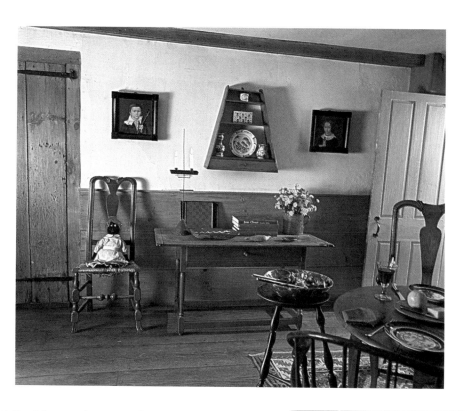

Looking at the ease of a room at home with American antiques, it seems hard to believe that our Colonial furniture was out of favor for almost a century after the Revolutionary War. The craftsmanship and economy of line are especially adaptable to informality and naturalness in decorating. Here, the living room enlarges from a cluster of seating around the hearth to garden-view dining. The drop-leaf cherry table is a graceful Queen Anne of around 1760; the chairs are a Queen Anne tiger-maple armchair with a rush seat and painted Windsors. The miniature highboy beside the fire is a William and Mary piece. A pair of dignified children flank an early New England hanging shelf made of maple. They are portraits of the Brockmuller children of Pennsylvania, painted in 1832. The delicate side chair is in the Queen Anne style with a Spanish foot and crested back; the New England tavern table has breadboard ends.

Bristol blue gives a bright vitality to the cabinet-work and wainscoting in a guest bedroom and makes a pretty background for English delftware and creamware. The beautiful desk is a fine New England piece of around 1760; the lovely lady above it is a William Jennys portrait of around 1790.

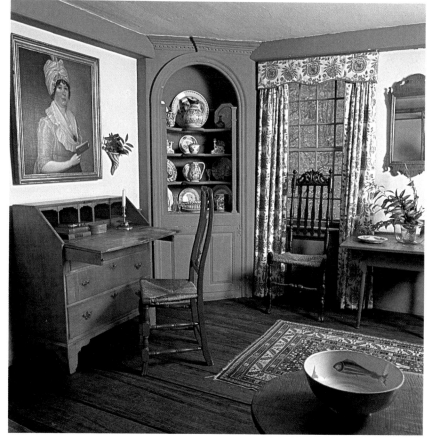

Trained as an interior designer, PATRICIA CORBIN was both a home furnishings editor and columnist for *House & Garden*. She is now a contributing editor to *The New York Times*, where she writes exclusively on styles and tastes, both current and historic. Her first book, *All About Wicker,* traces the history of wicker furniture.

ERNST BEADLE's photographs have appeared in Hearst and Condé Nast publications and in his book, *Decorating with Flowers*.